IMAGES
of America

NAHANT

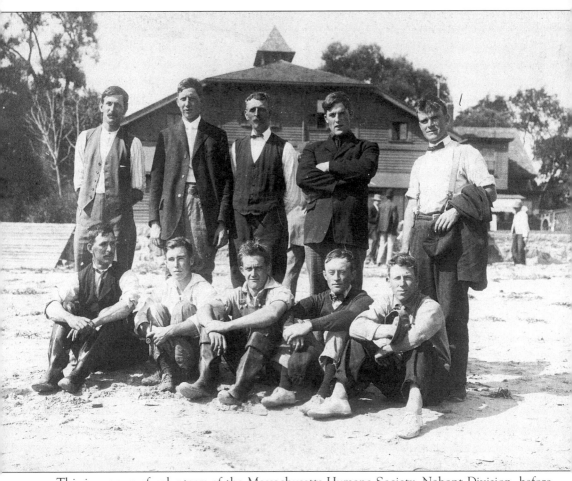

This is a group of volunteers of the Massachusetts Humane Society, Nahant Division, before 1898. A life saving station on Curlew (Longfellow) Beach predated the one at Short Beach. Shown here are the following, from left to right: (front row) Elmer Coles, Herbert Wilson, Sol Alley, Alfred Johnson, and Charles Vary; (back row) George Coles, Earl Dow, Herbert T. Coles, Arthur Robertson, and Joe Devaney.

IMAGES
of America

NAHANT

Christopher R. Mathias
and Kenneth C. Turino

ARCADIA

Published by Arcadia Publishing,
an imprint of Tempus Publishing, Inc.
2 Cumberland Street
Charleston, SC 29401

Printed in Great Britain.

Library of Congress Catalog Card Number: 99-62957

For all general information contact Arcadia Publishing at:
Telephone 843-853-2070
Fax 843-853-0044
E-Mail edit@arcadiaimages.com

For customer service and orders:
Toll-Free 1-888-313-BOOK

Visit us on the internet at http://www.arcadiaimages.com

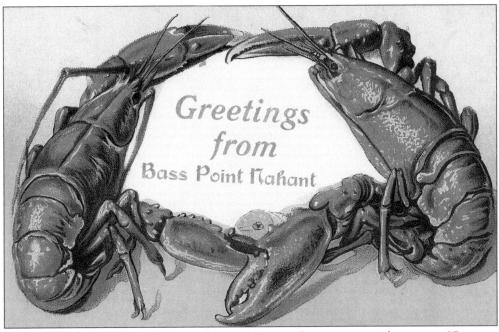

This postcard of 1908 harkens back to Nahant's days as a seaside resort. (Courtesy Paul Wilson.)

CONTENTS

Calantha Sears, a lifelong Nahanter, has from her youth been involved in Nahant's civic and social life. She has served the community well in a wide variety of ways. As one of the founders of the Nahant Historical Society and its first president in 1975, she has actively sought to collect, preserve, and teach the rich history of the seaside community she proudly calls home.

This book is dedicated to two people
who have steadfastly sought to promote and preserve the history of Nahant:
the late Stanley Paterson and Calantha Sears.
The authors particularly wish to acknowledge their indebtedness to Calantha Sears
for her support and assistance in researching this publication.
The authors are grateful to all those institutions,
particularly the Nahant Historical Society and the Nahant Public Library,
who gave access to their superb photographic collections.
Dan DeStefano of the Library should be singled out for his assistance.
Unless otherwise noted, all photographs are from the collections
of the Nahant Historical Society or the Nahant Public Library.
The Lynn Museum also loaned generously from its holdings.
Many individuals allowed the use of personal photographs,
including Paul Wilson whose extensive collection was of great use.
Family photographs from Bob and Mary Carey, Catsy Fowle, the Hall family,
and Roz Butler Puleo helped to round out the book.
Lastly, the authors wish to thank Diane Shephard,
for typing the manuscript and offering editorial advice,
and Ben and Sally Mathias, as well as Rhonda Massie, for their patience and support.

INTRODUCTION

Geographically, Nahant is two islands connected to each other and the mainland at Lynn by a picturesque sandy barrier beach. This 2-mile causeway separates Lynn Harbor from Nahant Bay. The name "Nahant" was the Native-American term for the area and meant "twins." From the earliest settlement by Europeans, it was considered to be part of Lynn and was used by farmers as a place to graze their livestock. The ever-present danger wolves posed to early settlers made the use of Nahant ideal. Its isolation in the ocean made it a simple matter first to eliminate all the wolves from the islands and then, with a short fence across the causeway, to keep other wolves out and all the cattle in.

This agrarian character with some settlement—mostly farmers and fishers—lasted until the late 18th century. In the first decades of the 19th century, noted Salem diarist Reverend Doctor William Bentley documented his trips to Nahant, noting things of scientific and aesthetic interest and also that a trip to the shore could be both healthy and enjoyable.

The second decade of the 19th century saw the discovery of Nahant by the elite of Boston. The change in attitude regarding being near and in the sea, as well as the crowded and unpleasant conditions of summer in the city, brought people out to stay at simple boardinghouses. They enjoyed the rugged environment and basic fish dinners the area had to offer.

Hotels sprang up in the 1820s, notably the Nahant Hotel at East Point, which could accommodate a number of people in a luxurious manner. Visitors now came from much farther afield as Nahant became known as one of the premier resorts in America. Those who wanted more privacy built "cottages," which were seasonal mansions to rival Beacon Hill or Back Bay townhouses. Many famous people of the day, including Henry Wadsworth Longfellow, Louis Agassiz, and Henry Cabot Lodge, soon had residences there. In 1853 Nahant separated from Lynn and formed its own town, partly over the right to serve liquor, since Lynn was a "dry" town.

The natural beauty of the area was celebrated in the travel literature of the day and in the works of such well-known artists as Fitz Hugh Lane, Thomas Chambers, William Bradford, and Robert Salmon. Maurice Prendergast and the artists now referred to as the Lynn Beach painters continued the tradition.

There were also recreation and amusement parks. First came the Maolis Gardens, a genteel park for relaxing by the seaside where patrons could take a picnic or eat in a restaurant, play on the swings, or observe nature from the vantage point of the "Witch House." Later, for those

seeking more entertainment, there was the carnival-like atmosphere of the Bass Point area and its midway. A number of hotels, theaters, bowling alleys, restaurants, and amusements catered to those looking for an exciting day away or a more extended lively vacation.

All this was possible because transportation had become very extensive. There were at least three piers where steamers brought passengers from Boston, Lynn, and Revere seasonally. Horse-drawn "barges" carried people over from Lynn on the hard sand at low tide and after 1849, when the road over the causeway was finished, could run on a regular schedule independent of the tides. The Lynn and Nahant Street Railway connected Nahant with the rail station in Central Square, Lynn, in 1905. This was a summer commuter's dream. Families could live full-time in Nahant while the breadwinner could easily get into Boston by sea or rail.

Although the hotels and amusement parks are long gone, Nahant retains its close ties to Boston. Its proximity to the Hub is ideal for traveling into the city, but because it is isolated in the sea, it still retains a character all its own. Spectacular views of Boston as well as the rest of the North Shore abound and many sea- and shore-based recreational opportunities are easily at hand.

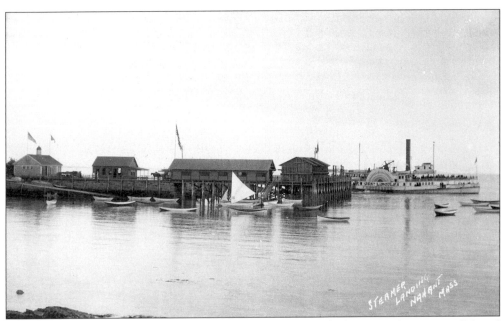

This photographic postcard of Tudor Wharf in 1910 captures the beauty and serenity still found on Nahant. The sender of this card wrote, "Went down to Nahant last Monday . . . Have been having a glorious time." (Authors' collection.)

One
BEFORE THE CAMERA

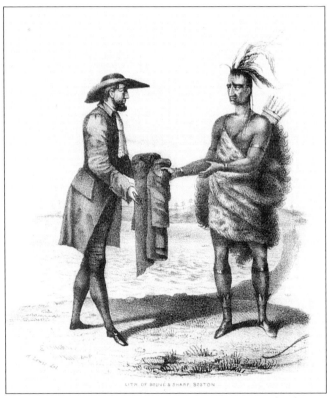

Drawn by historian and artist Alonzo Lewis, this illustration appeared in his 1844 edition of *The History of Lynn*. It depicts Poquanum, the Sachem of Nahant, selling the islands to Thomas Dexter, the great-great-grandfather of Paul Revere, for a suit of clothes in 1630. Poquanum was not getting a bad deal for the time since clothing, or any cloth, was extremely valuable. In 1657 Dexter brought a lawsuit against the town of Lynn claiming he owned Nahant. He ultimately lost his case, although he was "granted liberty to tap the pitch pines . . . for the purpose of making tar." (Courtesy Lynn Museum.)

This is one of the earliest views of the Nahant Hotel as shown from Forty Steps. Colonel Thomas Perkins opened the hotel on June 4, 1823. The Boston papers stated, "This magnificent establishment is now open for the reception of visitors to the most delightful spot on the American coast for health or pleasure . . . The hotel is capacious and filled with every convenience." The building consisted of two stories with an additional two in the roof. A large porch surrounded the hotel. The outbuildings included a billiard room and a bowling alley. The artist of this engraving, done in the mid-1830s, was Mary Jane Derby (1807–1892) of the Salem merchant family. It was printed by the Pendleton firm of Boston for which she was a freelance artist. (Authors' Collection.)

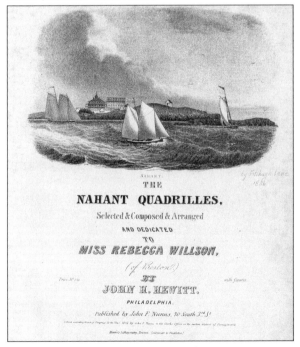

Noted Gloucester luminist painter Fitz Hugh Lane began his career as a lithographer. Among the first works he created was this piece of sheet music entitled *The Nahant Quadrilles*, dated 1836. The scene depicts the rocky coast of East Point with three ships in full sail and the Nahant Hotel with its addition to accommodate a larger dining room and more guest rooms.

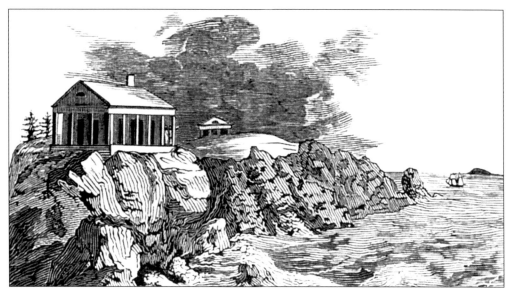

A *Visit to Nahant*, by "A Lady," was published in 1839 and described the wonders of the seaside village and its beaches. This illustration appeared in the book and the following quote aptly describes the engraving: "The travelers approached Nahant and beheld that bold promontory rising from the fair bosom of the ocean, with its picturesque gray rocks, dotted with beautiful white villas, or pretty cottages, presenting a scene to delight the eyes of the painter or poet." Perhaps this is the Nahant Hotel billiard hall in the foreground and the Mifflin house in the distance with Egg Rock on the horizon.

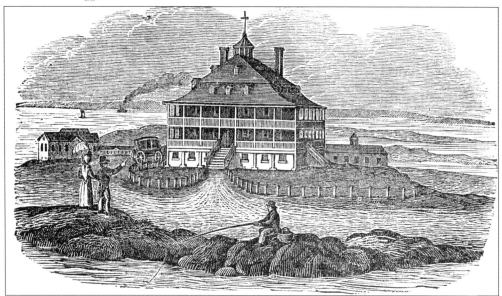

John Barber's *Historical Collections* (1839) contained this illustration and quoted historian Alonzo Lewis: "Nahant is much visited by persons for the improvement of health, and by parties of pleasure . . . A spacious and elegant hotel has been erected of stone, near the eastern extremity." Another contemporary writer called the hotel "pretentious" and "squat like a toad." The popular image of the hotel appears on several engravings and even a Staffordshire plate. (Authors' collection.)

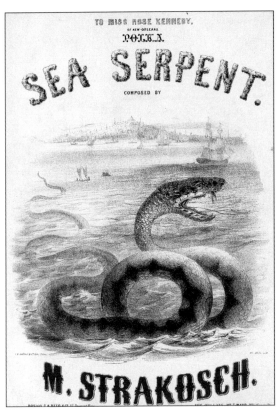

The notorious Sea Serpent made his first appearance in Lynn and Nahant on August 13 and 14, 1819. He had been sighted earlier that year in Boston and two years prior to that off Gloucester. Saugus writer Benjamin F. Newhall described the serpent as follows: "As he turned short, the snake-like form became apparent, bending like an eel. I could see plainly what appeared to be from 50 to 70 feet in length. Behind his head appeared a succession of bunches or humps upon his back." Hundreds of spectators viewed the Sea Serpent. A polka of the mid-19th century commemorated the event.

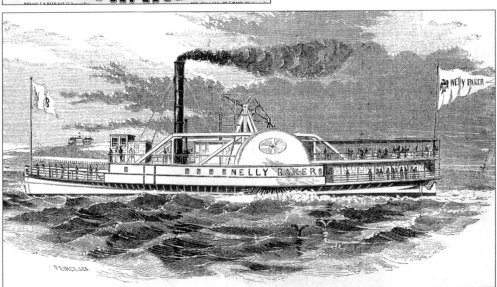

"A trip to Nahant and back in the *Nelly Baker* is one of the most refreshing excursions that can be taken," reads an article in an 1854 *Ballou's Pictorial*. Steamboat service from Boston to Nahant began in 1817 and continued until 1916. Daniel C. Baker, the third mayor of Lynn, was involved in the Nahant Steamboat Company, which built the *Nelly Baker*. The steamboat, in service from 1854 to 1861, was named after Baker's daughter. During the Civil War the boat was used as a transport and hospital ship. (Courtesy Paul Wilson.)

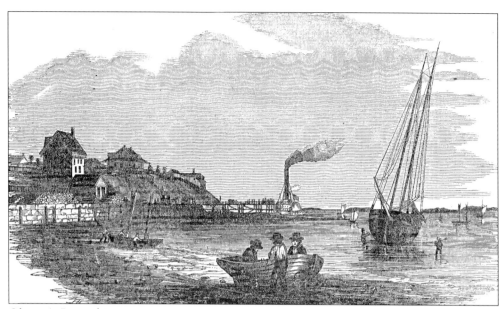

Gleason's Pictorial Drawing Room Companion of 1855 published this engraving of the steamboat landing off of Vernon Street. N.P. Willis wrote in 1836, "The hoi polloi go there by steam" to visit the hotel.

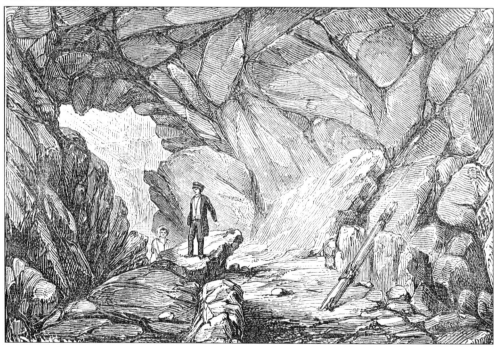

As an early resort possessing spectacular views and a number of hotels, Nahant also offered "many natural curiosities on the peninsula that attract the eye of the visitor." Chief among these was Swallow's Cave, shown here in an 1852 illustration. Numerous swallows have built their nests in this cave, which can only be entered at low tide under a high cliff. Visitors could also delight in Pulpit Rock, Spouting Horn, and the Natural Bridge, all of which appeared in various illustrations.

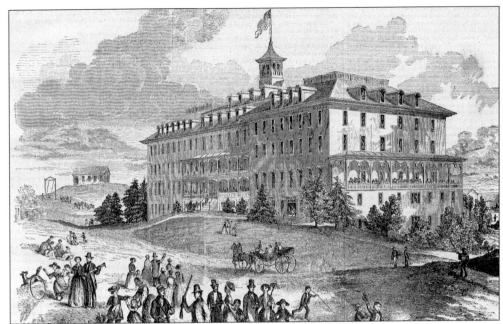

By 1855, the date of this engraving, Nahant had become one of the nation's leading summer resorts. The newspaper article accompanying this illustration stated, "There are few watering places in the United States more widely known than Nahant." The Nahant Hotel (shown here) had been enlarged several times and remodeled in 1855. Visitors can be seen in various recreational pursuits: hunting, fishing, strolling, swimming, and rolling a hoop. The hotel now possessed "every requirement of comfort and luxury . . . The house is thronged with company, the table is liberally catered for, and within doors everything is as agreeable as the scenery is attractive without."

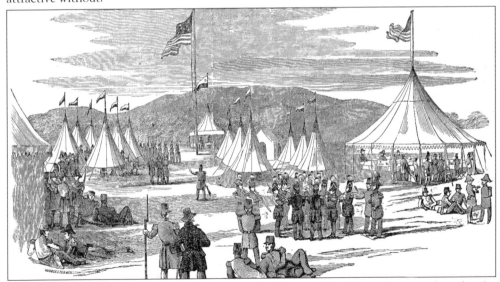

In 1851 the Boston Independent Cadets visited Nahant. This illustration was done by the "artist at the hour when the band was performing at the entrance of the camp." Later in the century, from 1869 to 1880, the encampment by the First Corps of Cadets of Boston was an annual event.

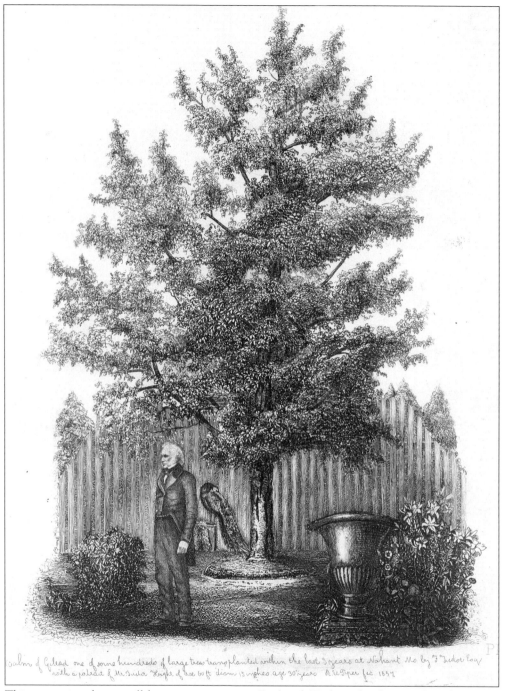

Palm of Gilead one of some hundreds of large trees transplanted within the last 3 years at Nahant Mo by F Tudor Esq with a portrait of Mr Tudor Height of tree 60 ft diam 15 inches age 30 years R.U. Piper fec 1854

This engraving shows well-known entrepreneur Frederick Tudor, who first purchased property on Nahant in 1824. Tudor is shown with one of the hundreds of trees he planted. Beginning in the 17th century, trees on the island had been cut down for firewood and by the 19th century Nahant had been deforested. With the encouragement of William Wood and the further encouragement of Tudor, tree-planting took place. These engravings were done for *The Trees of America* by R.V. Piper, M.D., of Woburn, Massachusetts, in 1855.

Dr. Piper moved to Nahant and lived in a house at the corner of Valley Road and Ocean Street. He had previously written a book on surgery and taught drawing and painting while living on Nahant. This image depicts the South Road, later renamed Willow Road.

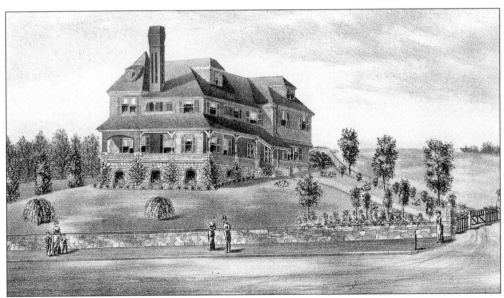

Photography had been gaining in popularity in America since its invention by William Henry Fox Talbot (1800–1877), and France's Jacques Louis Mande Daguerre (1789–1851), but it would not be until after 1897 that photographs, specifically half-tones, were used in newspapers. Lithography like this 1884 depiction of the J.T. Wilson house was still the main way of distributing images. Little changed today, this landmark house of 1882–83 is set on a hillside at 80 Spring Road. The house originally belonged to, and was built by, J.T. Wilson. A builder by trade, Wilson also held several local offices, serving on the school committee, as a library trustee, as selectman chairman, and as the town moderator from 1877 to 1898. He was also a local trial judge from 1876 until his death in 1914. (Authors' collection.)

16

Two

BY THE SEA

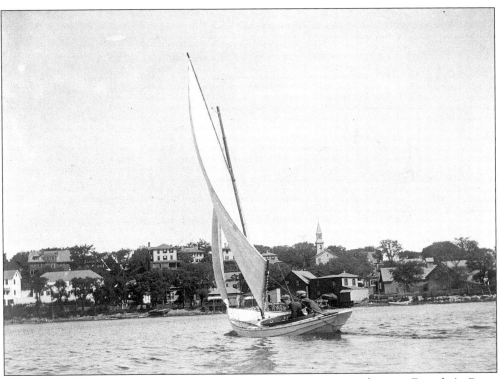

Henry Colby Wilson was a long-term town selectman. He is seen here in Dorothy's Cove, headed toward Tudor Beach in his well-beloved *Widgeon*. Tudor Wharf is out of view to the right in this 1890s panorama of the waterfront at Tudor Beach between Winter Street and Summer Street. The town clock in the steeple of the Village Church on Nahant Road was very important in town life and was specifically placed high so that it could be seen from a great distance both on land and from the sea.

This spectacular double-width postcard was prepared for the Nahant Drug Company at 33 Nahant Road sometime in the 1920s. The view of Saunders Ledge, which is off Spouting Horn

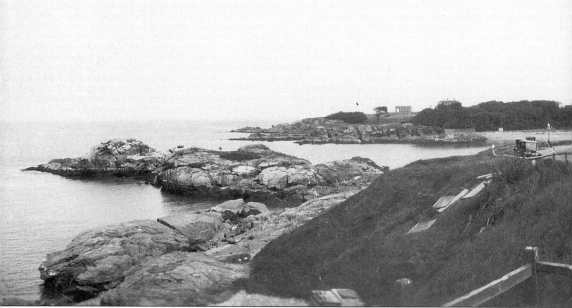

This matching card for the Nahant Drug Company shows East Point from the vantage point of the head of the stairs at Forty Steps Beach. Canoe Beach is visible above the cars on Nahant

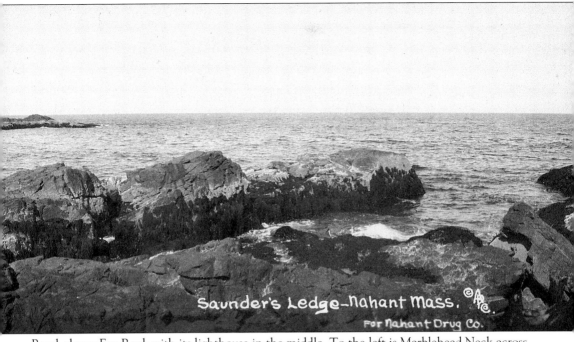

Road, shows Egg Rock with its lighthouse in the middle. To the left is Marblehead Neck across Nahant Bay. (Courtesy Paul Wilson.)

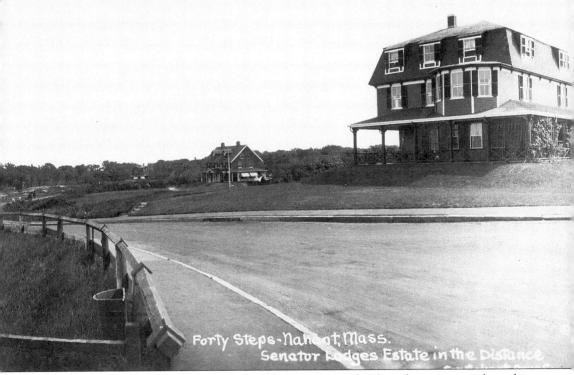

Road. Senator Lodge's estate is just to the left. The Otis and Gibson houses are to the right. (Courtesy Paul Wilson.)

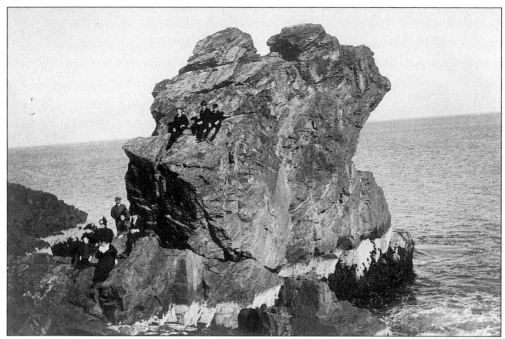

In the early 19th century, when Nahant became a seasonal resort for wealthy Bostonians, there were not many manmade sites to see or activities to play at. The focal point was the natural environment. Thus geographic anomalies, rock formations, and ocean views were the sites not to be missed during a holiday on Nahant. Here we see an 1890s view of Pulpit Rock, located at East Point, with at least ten formally dressed vacationers posing. It collapsed into the sea during a violent storm in 1951.

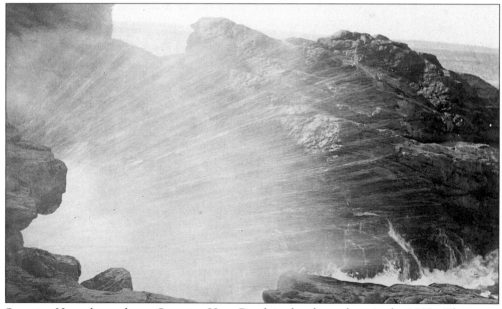

Spouting Horn, located near Spouting Horn Road, is also shown here in the 1890s. This was a rock formation that, when hit by a surging wave at high tide, would dramatically spew water into the air. It no longer spouts.

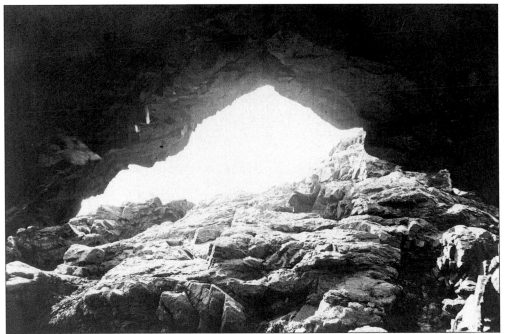

This 1879 view looking out of Swallow's Cave shows someone relaxing on the rocks above the entrance. The cave is on the water's edge at the base of the cliff at the end of Swallow's Cave Road. It runs a distance of about 100 feet to another seaward opening and access is restricted by tidal action. (Courtesy Lynn Museum.)

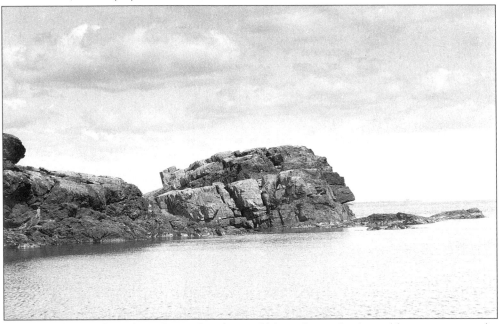

Castle Rock, seen here from Canoe Beach, would have been clearly visible to visitors at the Nahant Hotel and was a familiar destination for a walk. On the other side is Forty Steps Beach. Native Americans came to Castle Rock for summer encampments and sold their hand-crafted wares to hotel guests and residents. (Courtesy Lynn Museum.)

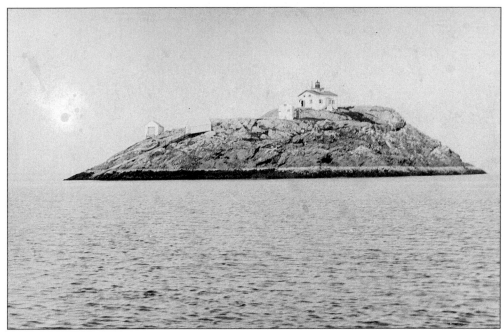

Egg Rock, located seaward from Nahant Bay, was quitclaimed to the federal government by the town of Nahant in 1855 so a lighthouse could be built. This first lighthouse was built of stone and stood until 1897, when a new, higher one was constructed. (Courtesy Lynn Museum.)

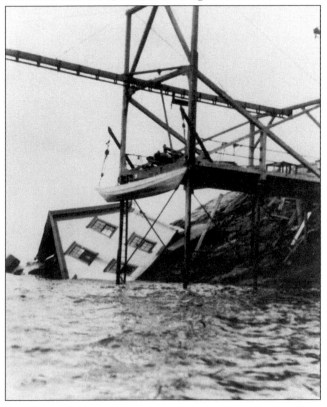

This dramatic photograph was taken in 1922, when the Egg Rock lighthouse was decommissioned. The wooden lighthouse keeper's home was sold for $160 and was to be moved off the island. After considerable time was spent preparing the building, it was poised over the sea, ready to move down to an anchored barge, when the ropes broke, dropping the building to the sea's edge. It hung on an outcropping for a few days but then washed into the water. The other structures remained on the island until they were cleared in 1927. It is now a bird sanctuary. (Courtesy Lynn Museum.)

This early stereopticon shows Forty Steps Beach with close to two dozen bathing houses running parallel to the cliff. Residents at East Point, seen bathing here, favored this beach because it was protected by enclosing rock outcroppings on either end and high cliffs behind. The Mifflin cottage watches over the beach. (Courtesy Lynn Museum.)

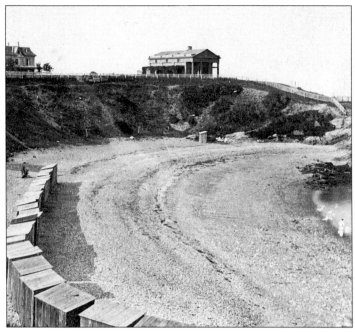

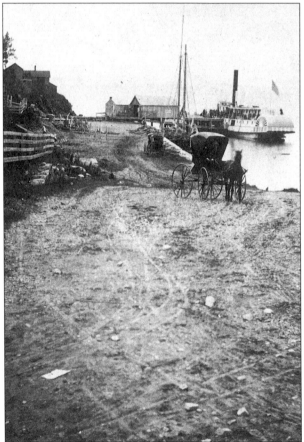

This stereoview of the steamboat landing was taken from Vernon Street near Swallow Cave Road. Construction was begun in the 1820s by Cornelius Coolidge, who had also helped the Nahant Hotel owners build Swallow Cave Road. The wharf evolved over a few years from a rather insubstantial wooden structure to one of massive stone walls that can still be seen today from Joe's Beach. This was the first deep-water wharf on Nahant and could be used without concern for the tides. Travelers from Boston and elsewhere could now alight directly onto the wharf and climb a stairway to Swallow Cave Road, where there was a waiting room, and then find a carriage to the hotel or other points of interest. Coolidge was a Boston merchant, architect, and real-estate developer who built at least eight houses in the East Point area as well as up to 50 houses on Beacon Hill in Boston between the State House and Charles Street.

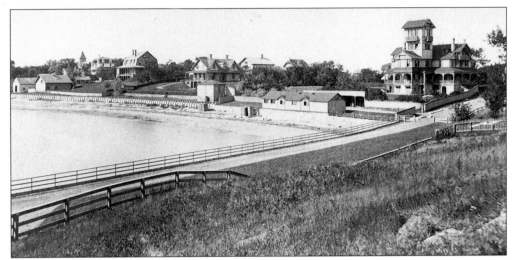

This 1879 view of Joe's Beach looks over the old steamboat landing off Vernon Street. The splendid and very eccentric Victorian house on the right began life as a much smaller building. Cornelius Coolidge built it about 1820 as the Nahant House Hotel. Joseph Peabody of Salem and Danvers had stayed here with his family prior to 1837 and in that year his sons George and Francis bought it and converted it into a private residence. Through extensive reconstruction it became the height of current fashion and existed until September 10, 1958, when it was destroyed by fire. (Courtesy Lynn Museum.)

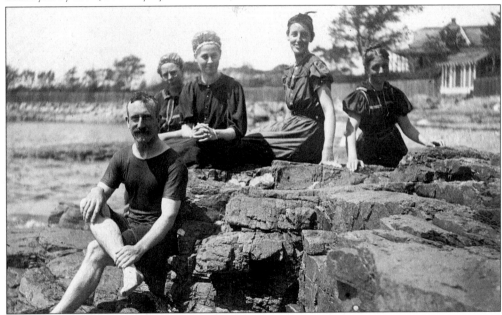

Benjamin C. Whiting (ticket seller at Nahant Wharf from 1897 to 1906 and assistant librarian), Harriett Lee Johnson (bookkeeper in Lynn), Carrie Stanley (music teacher), Hilda Poland (bookkeeper at Poland's grocery store), and Minnie Chaffee pose on Curlew Beach. This beach has been known as Cobbler's Beach (for shoemaker's shop nearby on Willow Road), Longfellow Beach (the poet's house overlooked it), and Boathouse Beach (for the Massachusetts Humane Society Life Saving Station). Notice Nipper Stage Point and the General John C. Fremont house in the background.

24

Wharf Beach and Marjoram Hill Park look rather idyllic here from Tudor Wharf on a calm summer day at the beginning of the 20th century. Marjoram Hill and Nipper Stage Point to the right were parts of General John C. Fremont's estate, later owned by the Frederick Tudor family. In 1906 Marjoram Hill, as well as the lowland behind Short Beach (the Lowlands play field) was purchased by the town for a public park, although it had been used informally by the public before this. The Village Improvement Society, founded in 1897 to help preserve the natural beauty of the town, and Town Forester George Abbott James were responsible for this improvement.

The Short Beach area is shown here c. 1890 from Stand Pipe Hill, approximately where the telecommunications tower is now located. Nahant Road curves up from Irishtown to the left; Greystone Road would later intersect at this point. The Lermond house is on the left side at the curve of Nahant Road, and just to the right of the road opposite Kennedy Court is the J.C. Shaughnessy family house, which was moved from the grounds of the Nahant Hotel. Notice the bathhouses at the beach. Revere can be seen beyond the ship heading into Lynn Harbor.

This 1890s photograph of Longfellow (Boathouse) Beach indicates how developed it had already become by that time. Partly visible to the far left is General Fremont's bathhouse. Proceeding to the right, in the trees is John E. Lodge's house, known as the Lodge Villa, Frederick Sears' house, and the tower of the Nahant Church, all located on Cliff Street. Underneath the church tower is Miss H.E. Hudson's house, which was moved here from Vernon Street and much remodeled. Furthest to the right is John Blanchard's house at the corner of Cliff Street and Willow Road. It burned in 1896, but Hon. George Duncan married Mrs. Blanchard soon after and built again on the same site.

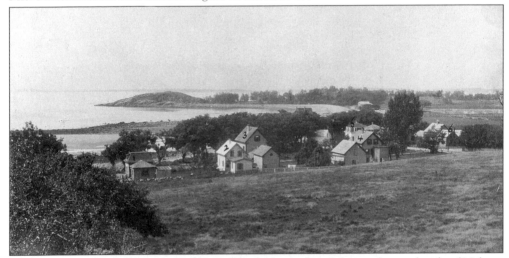

This 1890s view from the top of South Field, which was located near the south side of Nahant Road between Ocean and Winter Streets, looks out over Valley Road and Bailey's Hill toward Boston. The furthest two buildings to the left were owned by J. Bishop Johnson, a fish dealer. Next to it was the Kingsbury house, later moved to Emerald Road. Further to the right, on Valley Road, is the house of Francis B. Crocker, who owned and managed Johnson's Nahant Express from 1890 to 1923. On the extreme right is Piper Cottage, the home of Patrick H. Winn, on the site of the present-day Valley Road School. Across the street the roofs of the two Gove family houses are visible.

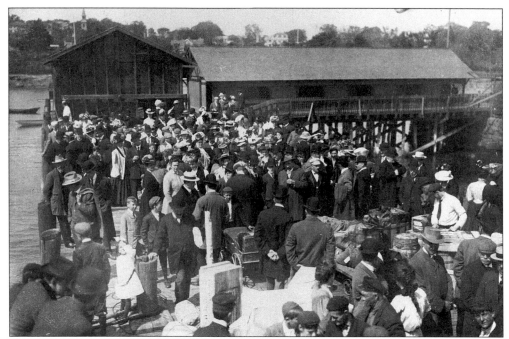

This image is great documentation of the crowds that would gather at Tudor Wharf to await the steamboat to Boston. Taken from onboard a steamboat, the view shows the entire wharf from the most seaward end. If examined carefully, the many very stylish "swells" can be seen, as well as the luggage and goods to be transported

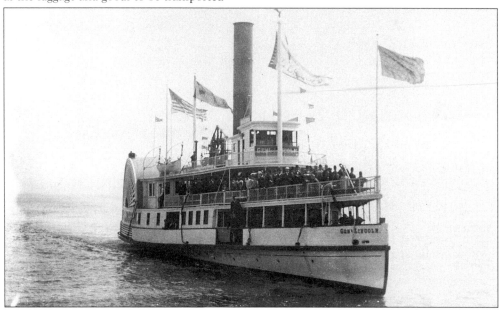

The steamship *Nahant* was built for and owned by the Boston and Nahant Steamboat Co. and served that route from 1881 to 1883. It was sold to the Nantasket Beach Steamboat Co. in 1884 and renamed the *General Lincoln.* In 1907 the newly formed Boston, Nahant, and Pines Steamboat Co. purchased the *General Lincoln,* and it served Nahant until 1916, when the federal government started impressing private shipping into duty for World War I.

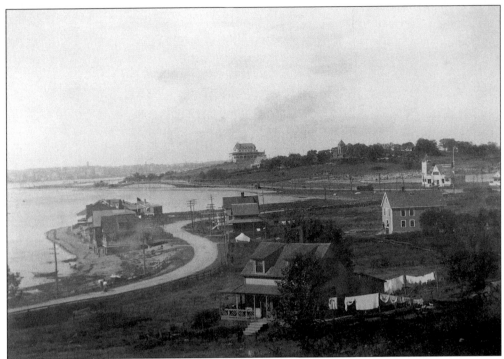

In the first decades of the 20th century, Nahant still had a rural character, as is demonstrated by this view of Castle Road from the top of Harbor View Hill. By contrast Lynn, seen in the distance, was highly industrialized. The house in the foreground, lived in by Mrs. Holland, a laundress for the summer people, was later moved to 76 Fox Hill Road.

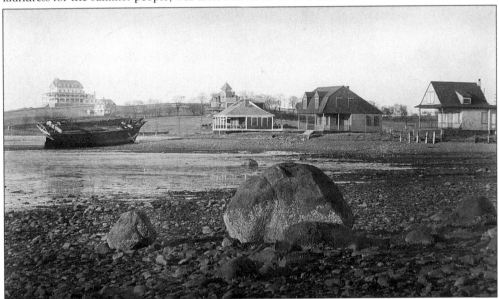

Here is a closer view of the houses fronting on Castle Road during the winter when they all appear to be closed up. In the middle is the towered Thomas Howe house and to the left is the gambrel-roofed house he built for his gardener. It must have been a violent storm that dashed the two-masted schooner *Georgianna* on the shore.

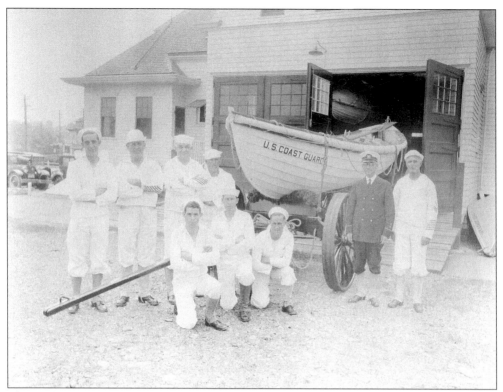

This early-20th-century photograph shows the crew of the U.S. Coast Guard Life Saving Station posing with one of the dories on the beach side of the building. Notice that inside there is another piece of equipment hanging in the rafters.

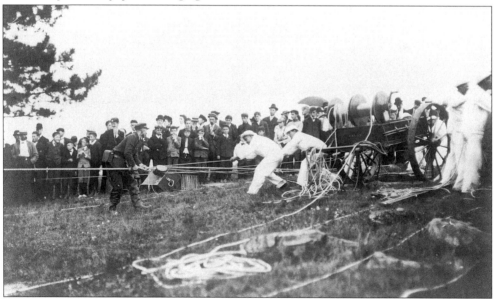

During the town's 50th anniversary celebrations in 1903, the U.S. Life Saving Service did a demonstration of a breeches buoy rescue technique at Marjoram Hill Park. The crowd looks on with great interest.

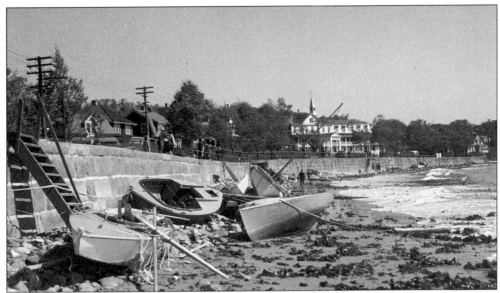

The hurricane of September 1938 did a lot of damage to the fleet at the town wharf. Tudor Beach is here strewn with Star boats, Monty Cats, the dory club launch, and other craft. The Tudor Hotel calmly looks out on the devastation while many curious citizens are inspecting the damage from the beach and the sea wall.

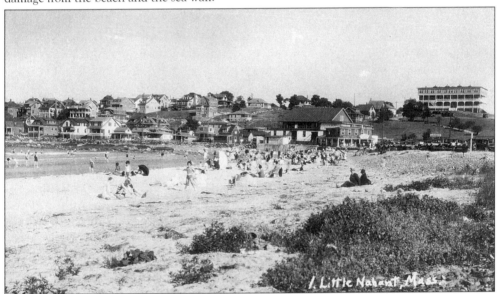

By 1938 Little Nahant was already quite densely populated and this mid-summer view of the Nahant end of Long Beach with its many bathers demonstrates the attraction. The large building on the hill is Shaw's Hotel, located at 3 Wilson Avenue. It was the former Nahant Beach Hotel the Carahar Brothers had moved from the Lynn end of Long Beach in 1901 and placed on land they purchased in 1896. It was bought in 1919 by Max Shaw and operated as Shaw's until World War II. Service was interrupted by a fire in 1929 that took off the top floor, but was soon resumed after rebuilding and expansion. The buildings just to the left on the beach were part of Bernard Carahar's beach resort, which consisted of a dance hall, bathhouse, and restaurant. (Courtesy Paul Wilson.)

Three

MAOLIS GARDEN AND BASS POINT

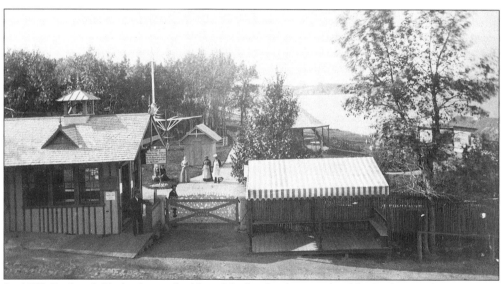

In 1859 Frederick Tudor began building Maolis Gardens on land he had recently purchased. These fields had long been known for their scenic beauty and were often the location of luncheon outings. Tudor decided to add amenities, enclose it, and charge a fee. It opened in 1860 and was bound by Ocean Street, Pond Street, the water, and the top of the hill. He planted and moved trees, laid out flower gardens, and built pavilions and swings. There was a bear den, cages for other animals, and eating facilities. The entrance, located on Ocean Street, is shown here in 1879. To the right of the elaborate gate is the covered area for patrons awaiting transportation, and further down the hill is where horses were tethered. Staff posing here include the chef and the ticket taker, among others. Note one of the "famous" stone lions carved by local stone mason David Hunt being cuddled by a young woman. Sparsely inhabited Little Nahant is in the distance. (Courtesy Lynn Museum.)

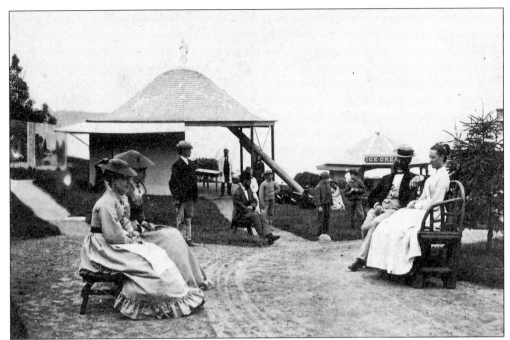

Inside the entrance was a pavilion called the Parasol that was originally supported only by the slanting post to the right, but as can be seen here was later partly enclosed and further supported. Mr. Tudor had both interior and exterior murals painted on many of the buildings. Just to the left of the Parasol is a scene painted on a nearby fence. The ice cream parlor is visible down the path to the right past patrons relaxing on rustic benches. (Authors' collection.)

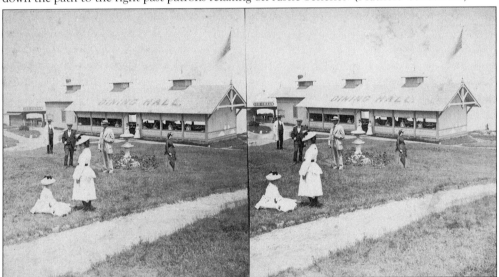

Further down the path, on the bank just above the breaking waves, was the Stick-style dining hall. Waitresses posing at the door and windows seem to be enticing holiday-makers to enter and enjoy a meal. The kitchen was behind the dining hall to the left. Two trained bears were kept on the grounds and taken down to the beach for seawater baths frequently. Once, one of the bears got away from his keeper and managed to get into the kitchen and devour some blueberry pies, after which he needed another bath. (Courtesy Paul Wilson.)

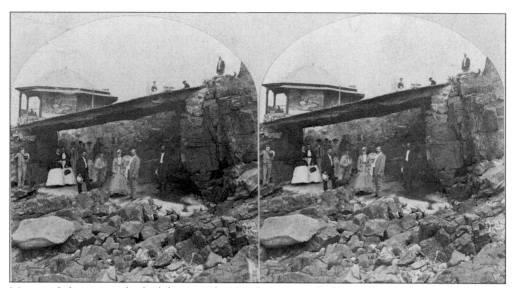

Many stylish visitors climbed down to the North Spring, which was covered by a rustic wooden roof supported by the cliffs on shore and tall ledges near the water's edge. Just above is the octagonal pavilion that was used as the ice cream saloon. Years before it served refreshments, this delicate structure contained a pool and fountain. One wall held an array of mirrors placed at specific angles so that, when standing in one spot, viewers could see Egg Rock in every mirror at one glance. Note that one of the wall paintings is clearly visible on the pavilion. (Courtesy Lynn Museum.)

Tudor built a hotel, the Maolis House, across Ocean Street from the entrance to the gardens between the current Maolis Road and Marginal Road. It opened in about 1860, but being built of wood it burned and was replaced with the brick structure seen here. It stood until just after Mrs. Tudor's death in 1884. Since Frederick had died on December 6, 1864, the running of the hotel as well as the amusement park was left to Mrs. Tudor, who cared for them quite successfully with the assistance of managers. (Courtesy Paul Wilson.)

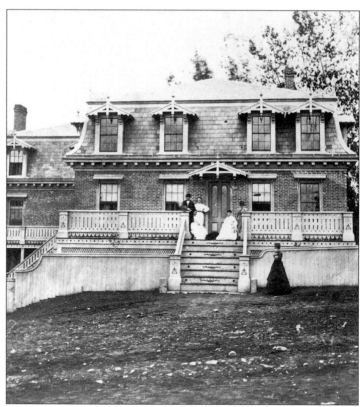

This view inside the park was taken looking back at the ticket taker's booth and entrance with the Maolis House beyond. Other attractions here included dancing, wheels of fortune, a target rifle range, croquet, and a Punch and Judy show. As other amusement parks developed in other towns, Maolis Gardens seemed dated and fell into decay. In 1892 it was taken down and many of the buildings were moved by barge to Bass Point to decorate the grounds of the Bass Point House. Mrs. Tudor's will of 1884 gave Maolis Gardens to the town as a public park but the town, not wanting the maintenance, accepted Central Wharf from the estate instead and renamed it Tudor Wharf. (Courtesy Lynn Museum.)

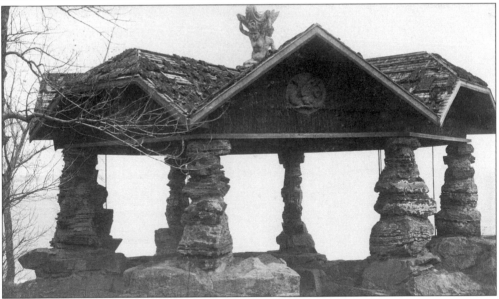

The only extant feature of the gardens (in 1999) is the Rock Temple, popularly known as the Witch House. Located on a hill at the corner of Marginal Road and Ocean Street, the octagonal open structure, with a roof of eight gables covered in hemlock bark radiating from the center, was designed by John Q. Hammond. The supports at each angle are columns of rough stones gathered locally and chosen for their color or unusual markings. Wooden carved medallions covered in gold leaf decorated the gable ends. The peak supported a gilded wood sculpture of a shell held up by two satyrs. The name possibly derives from a small cave nearby where tradition claims some "Salem witches" hid in the 1690s. In this cave Mr. Tudor had placed another carved stone lion. Close by on one of the enclosing fences another painting was executed, this time of a sea serpent.

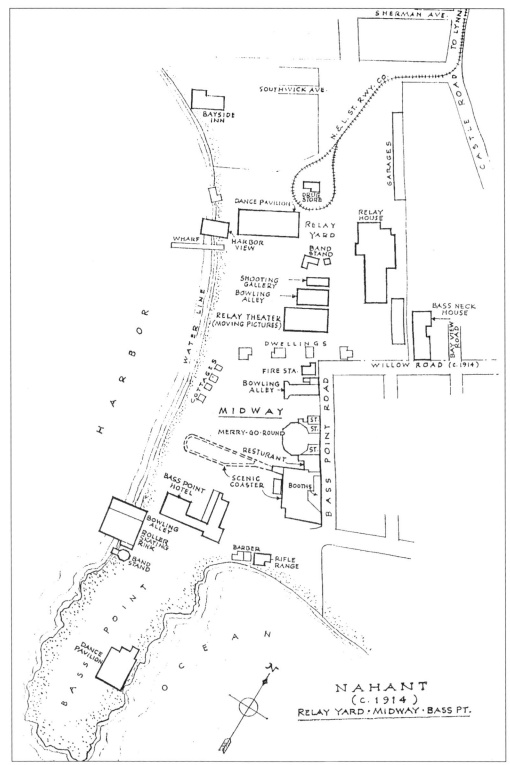

Kenneth A. Wilkie adapted this plan of the Bass Point Midway from a 1914 atlas of Nahant.

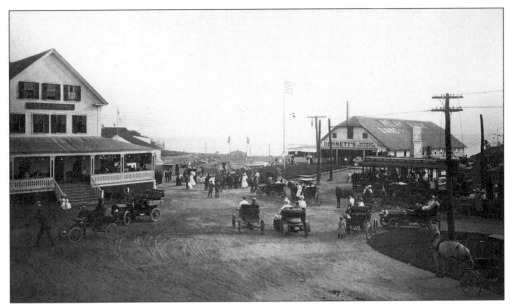

The Relay House was located at Relay Yard, which leads off Castle Road before getting to Gardner Road, and had views to Revere and Boston. The original portion of the hotel was built in 1862 by Nathan Mower, whose family ran it till 1882, when it was leased and finally sold to Eugene H. Brann in 1907. This 1908 view is a bustling scene with horse-drawn carriages, cars, and the terminus of the street railway. In the center is the departure point for the Lynn steamer and to the right is the dance hall. (Courtesy Lynn Museum.)

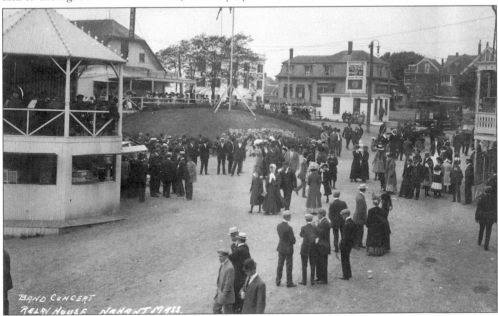

This image of the Relay House grounds in 1910 complements the previous photograph. It looks back at the original vantage point and gives a nearly complete understanding of the entire layout. A band is playing at the bandstand, and the concession booth is open below. The Bay Side Inn is behind the flagpole and the waiting area for the street railway is to the right. (Courtesy Paul Wilson.)

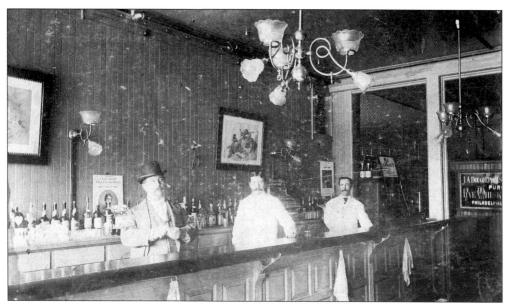

The Relay House bar seems quite comfortable in 1898 but was not the only attraction at the facility. In Mower's time, he was pleased to serve 300 patrons a week at the hotel, but by the time Brann (shown here in the bowler) had expanded operations, 9,000 people a week could enjoy all that was offered. The hotel had 50 guest rooms but the main dining room could accommodate 400 diners. There were also ten cottages, a shooting gallery, a roller rink for 800 skaters, a bowling alley, and a vaudeville theater.

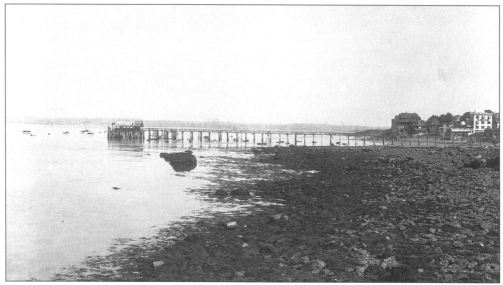

The Relay House Wharf, built in 1892, was at least 650 feet long with a narrow walkway out over the shallow water to a headhouse, but it was never intended for Boston boats. From 1894 to 1918 the smaller vessels of the Lynn Steamboat Company ran from here to Breed's Wharf in Lynn and for a time to the Ocean Pier amusement park on Revere Beach. The service could compete with the old horse-drawn Nahant barges but after the street railway was established the wharf became more recreational. The Bay Side Inn is on the right, with Lynn in the distance. (Courtesy Lynn Museum.)

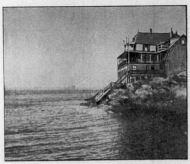

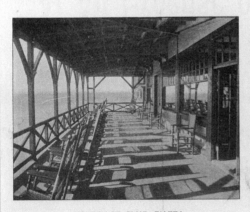
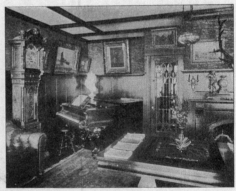
Walter Southwick bought this house and moved it to the water's edge on Sherman Avenue, raising it up and converting it into another small family hotel. It was never successful and in 1919 he came upon the idea of making it into a club. "The Anchorage Club" was advertised to have " the benefits of ownership of a cottage at the beach, for $5.00 per year." It sounded like a great idea but through his scheming there were numerous lawsuits, with Judge Southwick turning a profit anyway. The building remains as an apartment house. This advertising handbill was sent to prospective members.

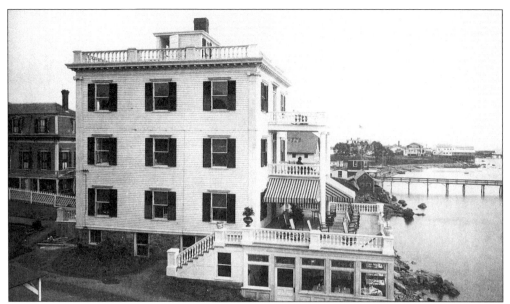

Located just northwest of the Relay House dance pavilion, the Bay Side Inn was built in 1907 by Walter Southwick on the modestly named Southwick Avenue. It had 25 rooms with seating for 100 in the dramatically sited dining room right above the beach rocks. Southwick was a lawyer and real-estate developer with extensive holdings in Bass Point, and was responsible for bringing the street railway and piped gas into the town. He later became Nahant's trial court judge. Although he was a colorful character, he was never regarded with affection. (Courtesy Lynn Museum.)

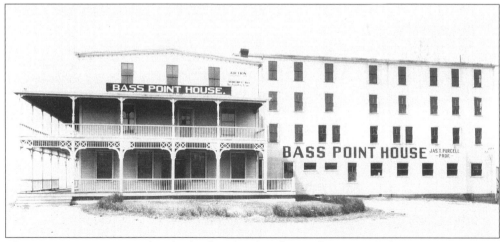

The Bass Point House stood at the landward end of the small point, called Bass Point, that juts out into the sea. Along with the Relay House and the Trimountain House, it anchored the entertainment district of Bass Point. The building began life in the 1870s, being built for Mrs. Tudor. It was renovated in 1891 but burned in 1894 and was renovated and reopened in the same year. Five hundred people could be served at a time in the 250-foot dining room and 500 more in the 22 smaller dining rooms upstairs. Like the Relay House, it also had numerous other entertainment structures on its grounds. The hotel was closed in 1936 and destroyed by fire in 1938. This Stuart Ellis photograph shows the vacant building awaiting auction. (Courtesy Lynn Museum.)

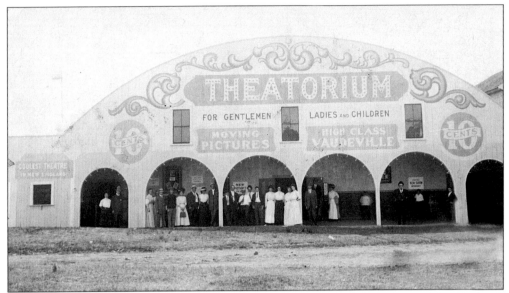

In 1909, the Bass Point House Theatorium boasted it was the coolest theater in New England. Showing both films and vaudeville acts, it had an entirely new line-up every Monday. This certainly drew patrons back frequently.

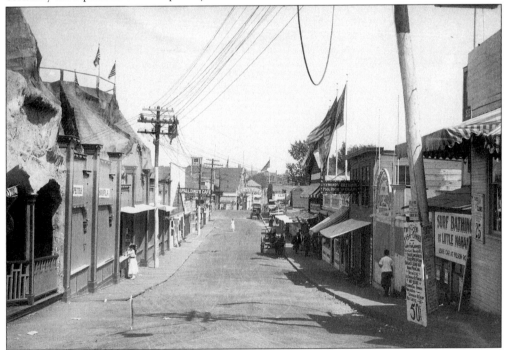

The Midway at Bass Point was the amusement area connecting the Bass Point House grounds with the Relay House. In this early-20th-century George Bliss photograph we can see the sign at the end for the entrance to the Relay House yard. There were shops selling postcards, souvenirs, candy, and drinks, as well as restaurants and activities such as billiards, a carousel, and the Scenic Coaster—a roller coaster built in 1911. On a pleasant summer day there may have been 40,000 people wandering Bass Point. (Courtesy Lynn Museum.)

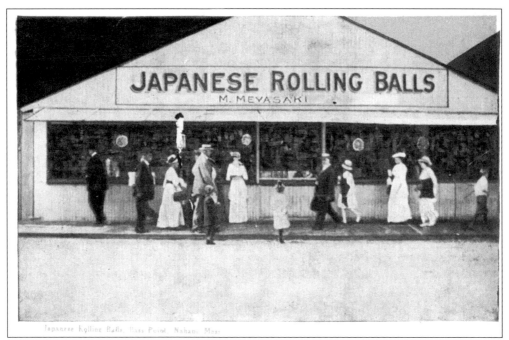

Japanese Rolling Balls, Bass Point, Nahant, Mass.

One of the amusements on the Midway was Japanese Rolling Balls, lending a bit of the exotic to the street. The proprietor, M. Meyasaki, also published this postcard of his enterprise. The young girl on the left in the previous photograph is standing at a concession stand located just this side of M. Meyasaki's business.

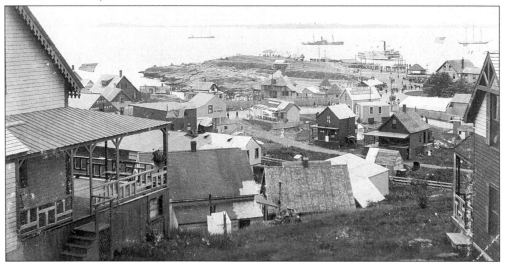

Looking down Colby Hill to Bass Point about 1898, the cottages that have been built to take advantage of the views and the proximity to entertainment can be seen. Bass Point Road runs horizontally through the middle of the photograph. The Bass Point Café can be made out on the left, with Frank Deshon fish dinners (corner of Sea View Avenue) in the middle and the Bass Point House (with the flag) on the extreme right. The steamship *Fred DeBary* is approaching Bass Point Wharf, which was built in 1892 for the Boston to Nahant traffic. The pavilion just to the right of the wharf was moved here from Maolis Gardens. (Courtesy Lynn Museum.)

41

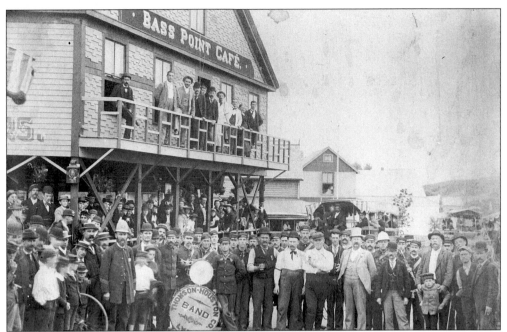

The Thomson-Houston Company Band poses in front of the Bass Point Café on Bass Point Road around 1890. It was probably a company outing before Thomson-Houston merged with Thomas Edison's company to form the General Electric Company in 1892. The police officer is the long-serving Chief Frank G. Phillips. Reputedly, the man with his arms folded walked backwards from Lynn to Bass Point. Why, will remain a mystery.

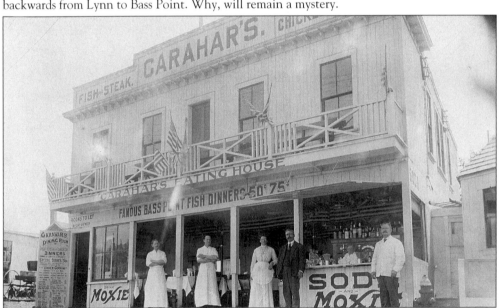

From 1895 to 1906 Richard P. Carahar was an express driver for the family business. By 1908 he was making shoes and in 1910 he ran this restaurant at 65 Bass Point Road. Even though it was in the open air it offered linen tablecloths and napkins. A very young man tends the soda fountain. The Carahar family has been involved in many different businesses in the area over the years.

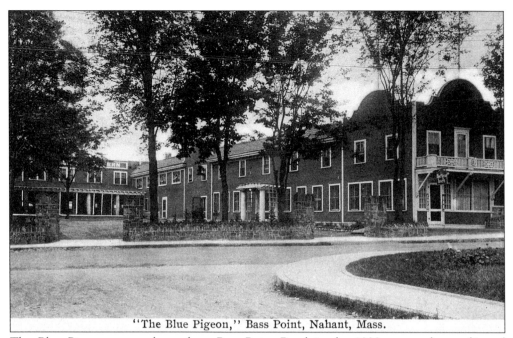

"The Blue Pigeon," Bass Point, Nahant, Mass.

The Blue Pigeon tavern, located on Bass Point Road in the 1920s, was a bar, café, and small hotel owned by Frank Keezer, who was also the proprietor of the Hotel Brenton. (Courtesy Paul Wilson.)

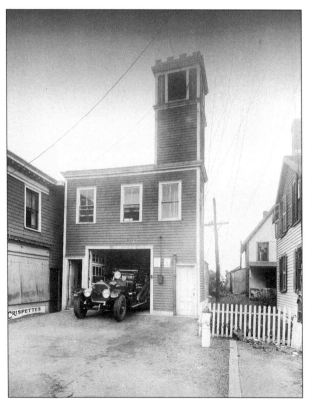

The Bass Point Engine House was built in 1894, the year the "Nathan Mower Hose Company Number Three" was organized. It would not be until 1896 that, as Fred Wilson writes, "this company was accepted by the town and put on the payroll of the fire department." It was the next year that the first fire alarm system was installed in the town with two large gongs outside the town hall and this engine house. Several fire bells, including the one in the hose tower here, were located throughout the town. The first motorized fire apparatus in the town was stationed here in 1910.

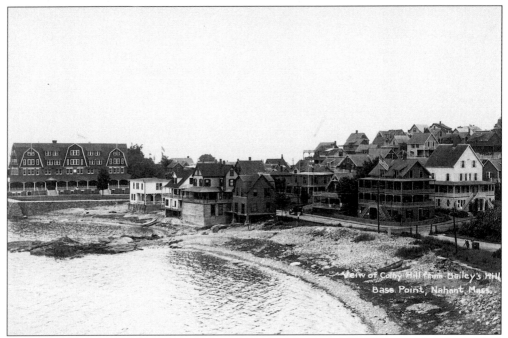

This view of Colby Hill from Bailey's Hill, taken before 1920, shows a densely packed neighborhood of small cottages. Real-estate agents had made their money, and families had built their small houses with little regard for safety or building codes, if such were known. It was a great area for fun and frivolity but potentially disastrous. (Courtesy Paul Wilson.)

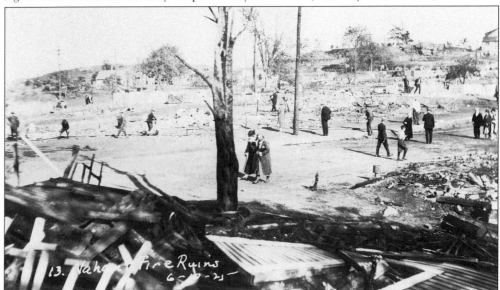

In June 1925 disaster came in the form of a fire that devastated Bass Point. An accident in one cottage quickly spread and soon Nahant and Lynn fire fighters were overwhelmed and called in a Boston fireboat. Everything was gone in a strip about 1,000 feet wide, from the top of the hill almost to the waterfront. The Hotel Brenton, Bass Point, the Trimountain House, and the Relay House survived but at least 70 buildings were lost. This photograph, taken just after the fire, shows Colby Hill from Irving Way.

Four

HOUSES AND HOTELS

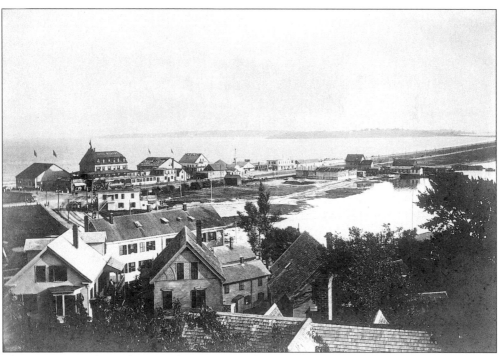

This 1901 view from the top of Sagamore Hill in Lynn shows the resort buildings at the entrance to Nahant on Long Beach before their removal. Included are the Hotel Nahant, the Trafton dance hall, casino, restaurants, and Oceanside Park. The Allan Hay Shipyard is visible to the right of the road. (Courtesy Lynn Museum.)

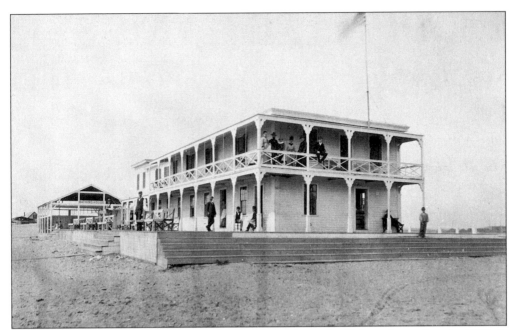

Samuel Soule built his Hotel Nahant on Long Beach at the Nahant-Lynn line in 1858. It burned and was rebuilt a number of times and it is seen here as a rather plain structure in 1879. The bathing house is to the left. (Courtesy Lynn Museum.)

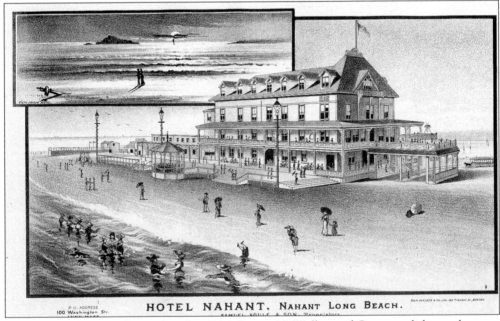

HOTEL NAHANT. NAHANT LONG BEACH.

The Hotel Nahant, as depicted in this 1884 George H. Walker and Company lithograph, was a grand delight, but by the end of the century the whole area was rather disreputable and the town fathers devised a plan to cede it all to the Metropolitan Parks Commission for a state bathhouse and reservation. In 1901 the buildings were auctioned and moved. The hotel was bought by the Carahar Brothers for $550 and moved to their property above Nahant Road on Little Nahant. (Authors' collection.)

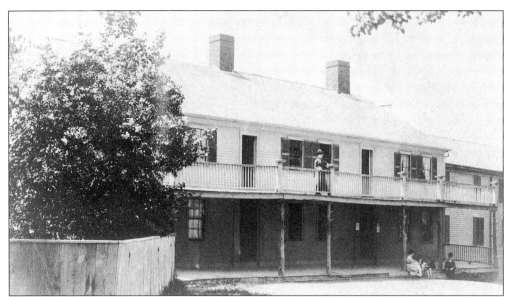

The Whitney Hotel is probably the oldest building in Nahant. In 1738 Samuel Breed owned it and ran it as an inn. In the mid-1830s Albert Whitney moved to Nahant to manage the Nahant House, which went out of business after a few years. He moved over to manage Rice's Tavern and in 1840 bought it and renamed it Whitney's. It became a boardinghouse, restaurant, and tavern catering to the middle class. Located near Forty Steps Beach, it still stands as a private house, although it has been somewhat altered.

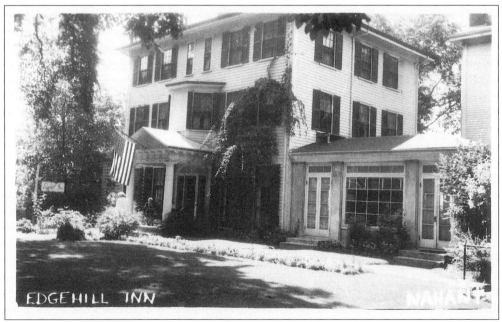

EDGEHILL INN

In 1889, Mrs. Annie Robinson purchased the Artemus Murdock boardinghouse across Nahant Road, near Frederick Tudor's house. In 1890 she opened the enlarged building, and in 1891 she renamed it the Edgehill Inn. It continued operation until the end of World War II and remains today as an apartment building. This 1950 postcard shows the original Murdock portion.

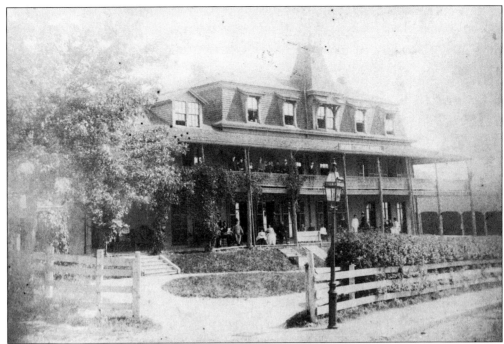

About 1854, Frederick Tudor bought the original Samuel Perkins cottage and moved it to Willow Road at Winter Street. He rebuilt the house and opened it as a summer hotel called Hood Cottage. In 1866, William Catto purchased it from Mrs. Tudor and personally managed the small hotel.

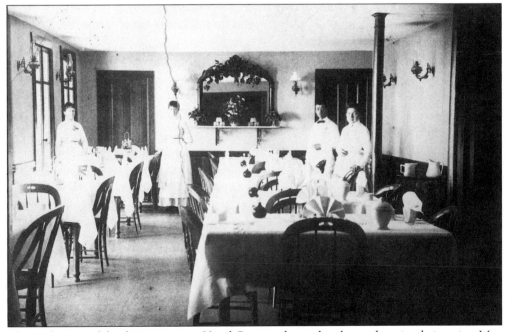

This early view of the dining room at Hood Cottage shows the elegant but simple interior. Mrs. Frank A. (Annie Henry) Gove is standing on the right. She came to Nahant from Scotland and worked for the Cattos at the Tudor Hotel.

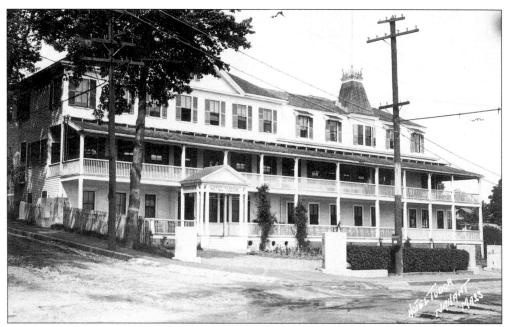

In 1894 William Catto greatly expanded Hood Cottage and renamed it Hotel Tudor. Its patrons were frequently overflow guests and relatives of the summer residents. From the piazza there were extensive views and persistent ocean breezes. Across Willow Road was the beautiful Tudor Beach for sea bathing. The building stood until 1945. (Courtesy Paul Wilson.)

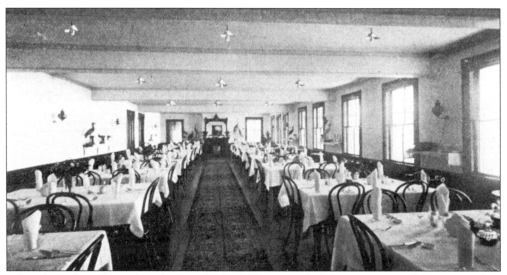

After the enlarged Hotel Tudor was finished, the expanded dining room could accommodate many more diners. Light poured in through the large windows and illuminated flower-bedecked tables. Stuffed birds and oil lamps decorated the walls.

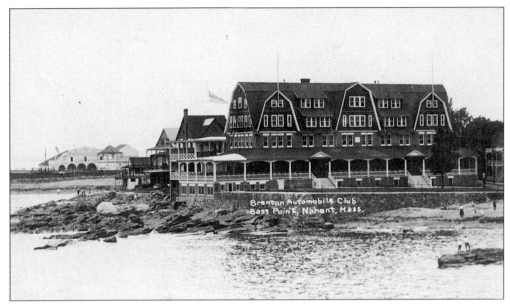

The Hotel Brenton was begun at Bass Point in 1908 and was opened in 1910 by Frank Keezer. It contained 55 sleeping rooms and at least 25 other public and service rooms. The dining room, which featured water views on three sides, could accommodate 500 diners at a time. The hotel also had a café, barbershop, bar, and wine room. (Courtesy Paul Wilson.)

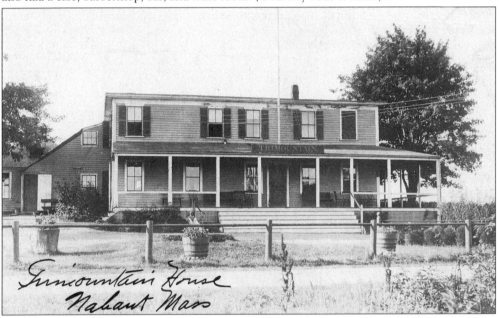

The Trimountain House opened as a hotel in 1876 in a house that Mrs. Tudor had built earlier at the foot of Bailey's Hill. Sylvester Brown, born in Lynn in 1834, was proprietor from 1876 to 1906. It had a seating capacity of 100. Tent camps were set up on adjacent land for those who could not afford to build cottages or stay at the hotel. In 1900 the federal government took over Bailey's Hill for a fort but leased the hotel back to Mr. Brown. In 1906 the hotel closed over a disputed liquor license but Brown remained there until his death in 1919. It was torn down in 1922. (Courtesy Paul Wilson.)

This undated photograph shows the view from the veranda of the Carahar Brothers' Grand View Hotel on Little Nahant. Looking toward Revere Beach and Winthrop, it was located on the easterly corner of Nahant and Wilson Roads. The ship in the middle distance is one of the Nahant-Lynn steamships and is headed for Nahant. This must have been a very entertaining spot to relax since all the shipping traffic in and out of Lynn and Revere had to pass by. The building burned in 1915. (Courtesy Lynn Museum.)

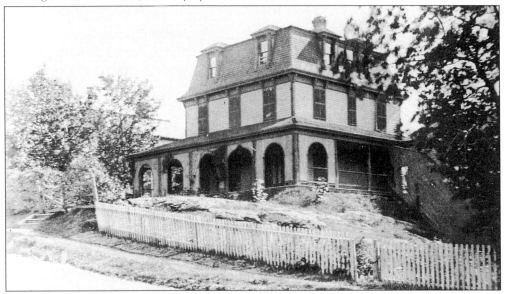

Although Henry Wadsworth Longfellow, the poet, first came to Nahant about 1850, he did not own a house until 1858, when he bought this house on Willow Road. From here he overlooked the fleet of boats anchored at Nipper Stage Point near Longfellow or "Curlew" Beach. He wrote "The Bells of Lynn" and other poems here. The house was destroyed by fire on May 18, 1896.

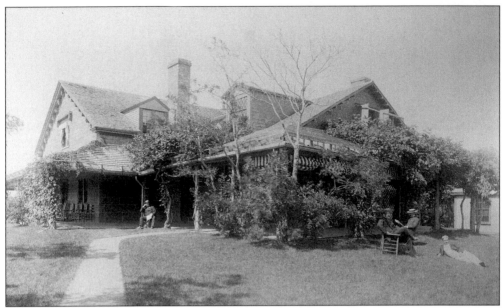

Frederick Tudor's summer cottage at 280 Nahant Road was one of the first built following the establishment of the Nahant Hotel at East Point. Constructed in 1825 so his mother could be near the summer social scene, the building was soon expanded beyond the original stone structure. Tudor, a Boston merchant known as the "Ice King," became a considerable landowner and had a great interest in horticulture. He was responsible for the planting of many decorative trees, orchards, and gardens, changing the landscape from barren treeless scrub land to a verdant, lush park land. This photograph shows his house on the Winter Street side when it was the Nahant Club, but still reflected Tudor's taste for gardens with the many vines trained over the veranda roofs. The club bought the house in 1888.

This fieldstone and shingle building at the corner of Spring Road and High Street was built by Frederick Tudor by 1850 and used as a fruit storage barn. The associated apple orchard was bounded by Spring Road, High Street, Coolidge Road, and the cemetery. The property was later purchased by Nahant builder J.T. Wilson, whose house was nearby at 80 Spring Road. His shop stood across the road and he used the barn for storage.

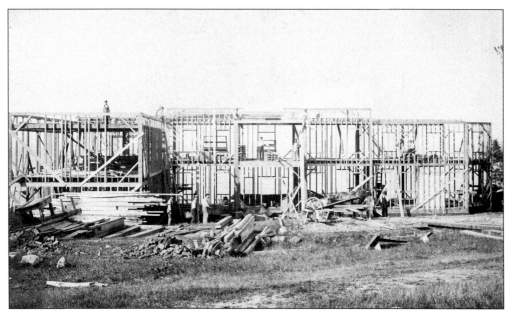

This unusual photograph is of the Samuel E. Guild house under construction in 1892–93. Located on the grounds of the defunct Maolis Garden at 66 Ocean Street, it is one of the finest examples of the Colonial Revival style in town. It was built by J.T. Wilson (Albert G. Wilson, superintendent) and a close observation shows at least a dozen of his craftsmen posing for the photographer. The house remained in the Guild family until 1941, when the Catholic Archdiocese bought it and a group of nuns took occupancy. It is now a private residence.

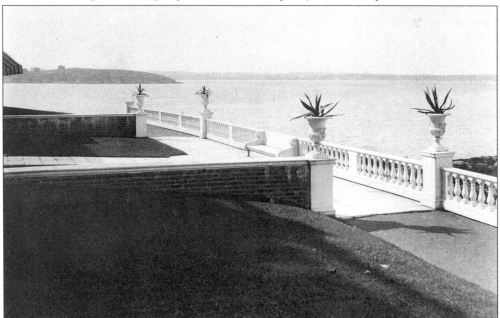

The ocean side terrace of the Samuel E. Guild house goes a long way toward explaining why Nahant was such an attractive location for a summer residence. A perfect complement for this spacious house, it had a view across Nahant Bay to Lynn, Swampscott, and Marblehead. Notice how few buildings are on Little Nahant to the left.

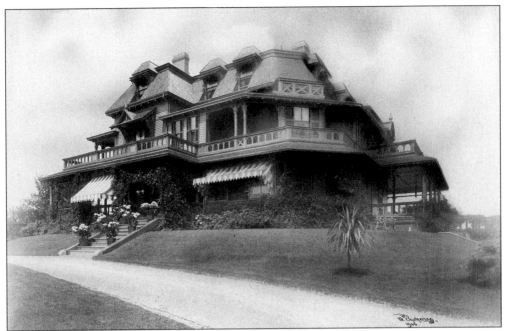

This 1906 Chickering photograph shows the house of Henry Cabot Lodge at East Point. Cabot's father, John, had purchased the land following the burning of the Nahant Hotel in 1861. In 1868, George Abbott James, who had married Lilly Lodge (Henry's sister), built this house on the site of the hotel and called it "East Point." When Cabot returned to Nahant in 1871 following his marriage and honeymoon, he occupied East Point and James began building Lowlands on the other end of the estate. East Point remained in the Lodge family till the military took it over prior to World War II.

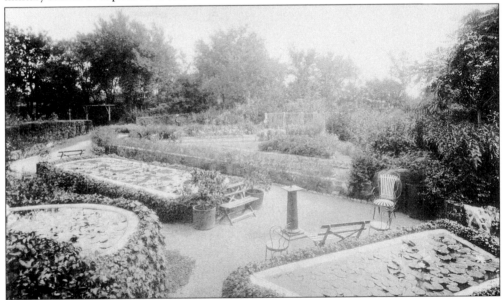

Gardens were an important part of the landscape in Nahant as well as elsewhere. This 1906 Chickering photograph shows part of Henry Cabot Lodge's grounds and includes lily ponds and a rose garden. (Courtesy N.W. Riser.)

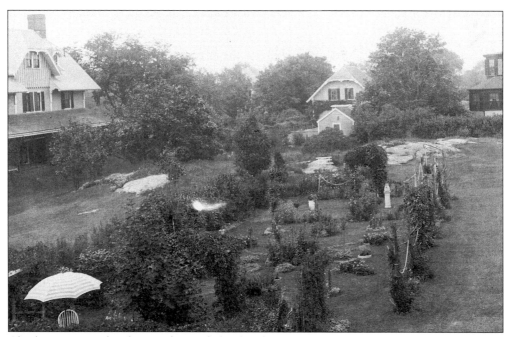

Charles Hammond Gibson cultivated this lovely garden behind his house at 2 Cliff Street. With no fences dividing adjacent properties a family compound was formed. The Stick-style house on the left (built in 1828, altered in 1858) and the barn straight ahead belonged to Samuel Hammond. (Courtesy Paul Wilson.)

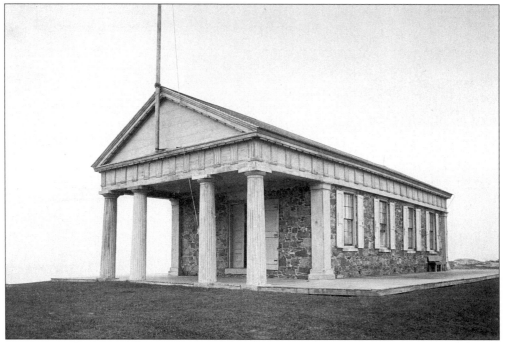

This beautiful but stark Greek Revival building with Doric columns was built as the billiard hall for the Nahant Hotel. After Henry Cabot Lodge owned the property it was used as a library and stood until the military demolished it and the adjoining Lodge mansion in 1943.

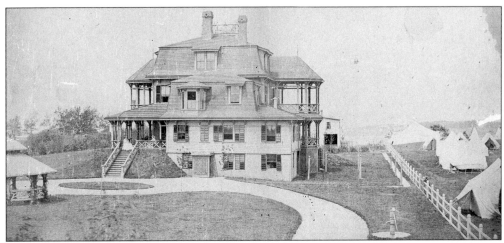

Two Victorian ladies are relaxing on the veranda of the Barthold Schlesinger house on Prospect Street in the 1870s. It survived into the 1930s and the laundry building and the barn still stand, having been converted into private houses. The tents in the field to the right were erected for the annual encampment of the First Corps of Cadets from Boston. This military unit of uniformed volunteers would arrive for a week of festivities during the summer season.

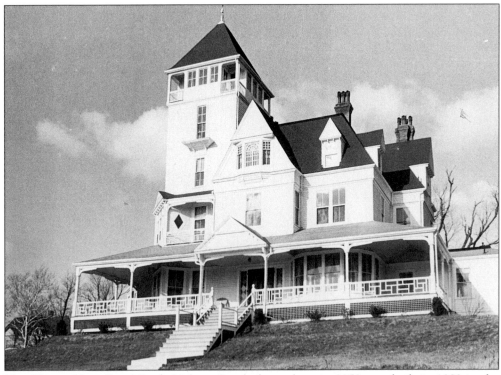

The "Tower House" at 9 Little Nahant Road, shown here in 1952, was built in 1880 in the Queen Anne style by J.T. Wilson for Thomas Howe. The design was drawn by the Boston architectural firm of Wait and Cutter, who also did the Middlesex County Registry of Deeds in East Cambridge. Mr. Howe owned a lard oil factory in Hunter's Point, NY, and a winter residence in Brookline, MA. When he died, the building passed ultimately to Percival Howe. Following his passing in 1927, the grounds were subdivided and the home was sold.

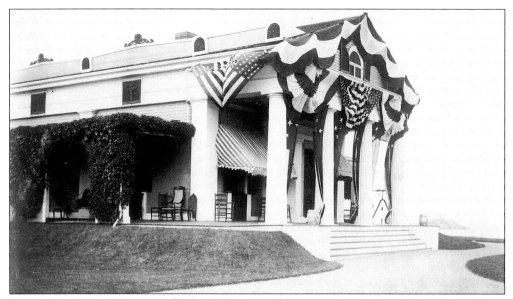

Samuel A. Eliot built his remarkable Greek Revival house on the cliff overlooking Forty Steps Beach in 1821. Unfortunately, he went bankrupt in 1857, and the property was purchased by Charles Mifflin. It remained in the Mifflin family until World War II, when it was occupied by the military, and it only returned to civilian ownership in 1965. This 1903 image shows it decorated for the celebration of the 50th anniversary of Nahant's founding. Egg Rock with its lighthouse can be seen in the distance.

The water pump on the estate of Harvard Professor of Zoology Louis Agassiz was a charming place to pose. Olive and Chester Grover are shown here in the 1890s. In later years Olive became a long-term and very popular teacher in town.

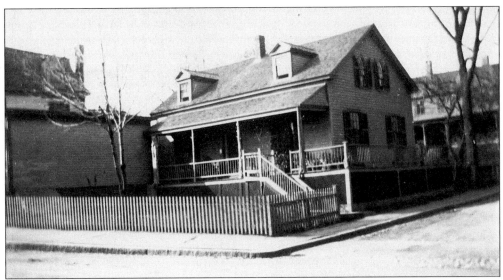

"Mountford Cottage" was built in the 1830s for Benjamin Crowinshield of Salem on Swallow's Cave Road, and inherited by his daughter, Mrs. William Mountford. It was occupied for at least one season by the poet Longfellow. In 1874 it was moved to the corner of Pleasant and Nahant Roads, and it was moved again in 1910–12 to Spring Road to make way for the town hall. It has since been torn down.

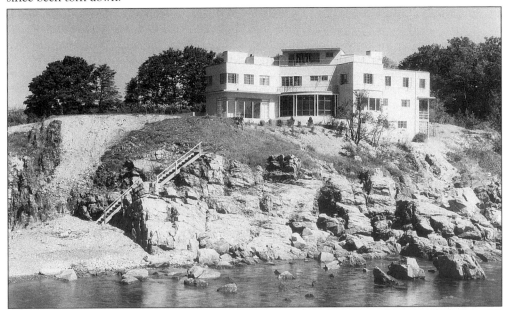

This art deco house was built in 1937–38 for Mrs. F. Haven Clark on the site of William H. Prescott's cottage "Fitful Head" on Swallow's Cave Road. It was designed by architect Harold B. Willis and was to be finished before June 18, 1938, the date Mrs. Clark's daughter Anne was to marry John Roosevelt, the son of President and Mrs. Franklin D. Roosevelt. John and Anne lived here until moving to California after World War II. In 1949, Abdul Madjid, the retired finance minister of Afghanistan, bought the property. This view, probably from the tidal Pea Island, shows its rugged and exposed position. After Anne Roosevelt's death in 1970, her ashes were disbursed into the sea from Pea Island.

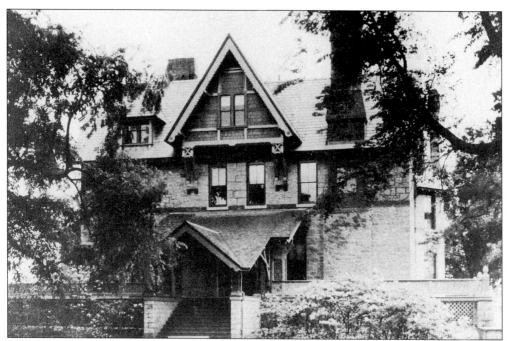

Lowlands, one of the grandest estates, was built by George Abbot James in 1871 and remodeled by Harmon Elliott in 1928. It was built of Quincy granite with 30-inch-thick walls at East Point, on the site now occupied by the Northeastern University Marine Science Center. In 1941, it was taken and later abandoned by the federal government.

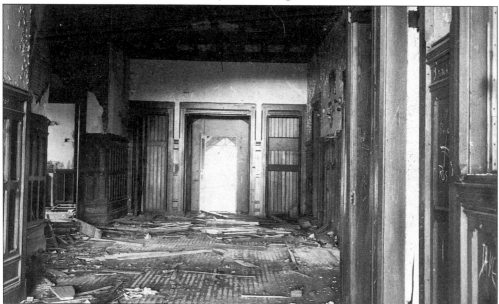

Lowlands served as the headquarters building for Battery B, 187th Coast Artillery Battalion (H.D.) at East Point during World War II. This photograph of the shabby but once-elegant interior of the entry hall was taken years after the military had abandoned the site in the early 1960s. Mr. Elliott removed all the interior woodwork and decorations of the living room and dining room in 1941 and installed them in his new house, Cas-el-ot, on Swallow's Cave Road.

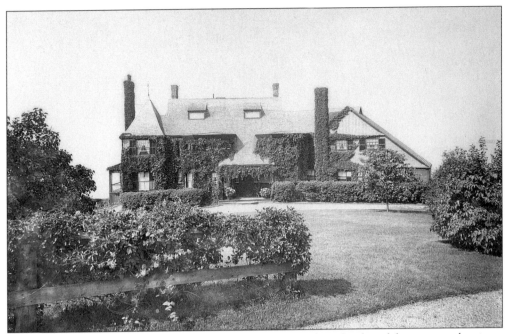

This 1939 photograph of the Sprague-Lowell house shows the splendor of the mature plantings. Located at the end of Swallow's Cave Road, this house was taken down in 1941–42 by Harmon Elliott to build Cas-el-ot. He also removed the Samuel E. Guild house on the adjacent property at 6 Swallow's Cave Road to create his garage and caretaker's cottage.

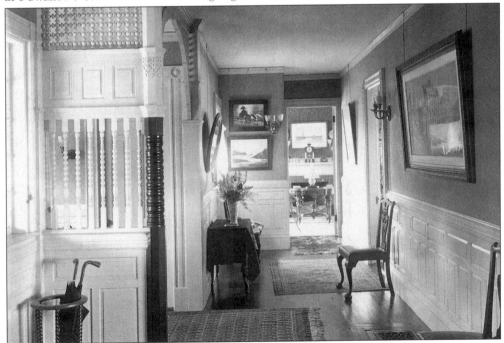

The entry hall of Dr. Francis Sprague's house is shown here before Mrs. John Lowell lived in it. The elegant and light-filled interior was well appointed with antique prints and paintings. The parlor can be seen through the open door in this Baldwin Coolidge photograph.

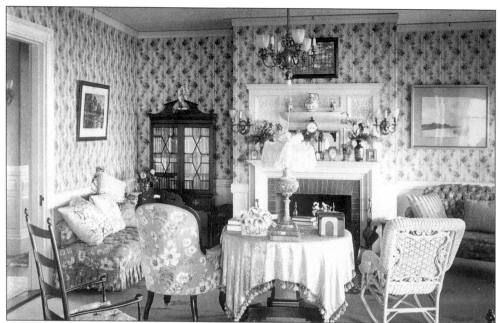

The living room of the Sprague-Lowell house reflects the comfortable style adapted for the summer with many flowers from the extensive gardens. It is fortunate that photographs still exist of this house to document the period before preservation was considered a valuable tool to keep history alive. In Harmon Elliott's efforts to improve his estates in Nahant, he managed to remove four significant buildings and lose one to the military.

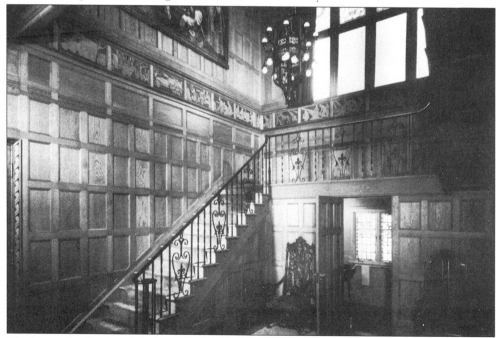

The baronial splendor of the entry hall to Cas-el-ot reflects a modern taste. Notice the frieze of automobiles, planes, and military scenes that runs along the stair walls. The chandelier is made from two Lowlands fixtures bolted together.

This stylish cottage at 179 Wilson Road was built *c.* 1953 and occupied in 1954 by Albert Cushing, a draftsman, and his wife, Bernice Eisenberg. Both were very active in town life. Clearly it is still under construction and features a castellated tower and Gothic arches in brick and stone. Located in a fast-developing area of Little Nahant, it commanded expansive views of Lynn and Swampscott. There still seems to be some undeveloped lots to the left. (Authors' collection.)

This 1949 photograph shows two cottages on Little Nahant. To the left is 97 Wilson Road, a summer cottage owned by Martin Swartz, a real-estate salesman who lived in Lynn. On the right is 95 Wilson Road, owned by John A. Flynn. Both of these cottages, now year-round residences, remain substantially the same but do have considerable alterations. (Authors' collection.)

Five
VILLAGE LIFE

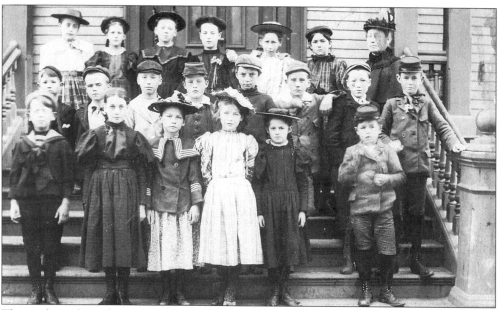

The students from the Intermediate School on Pleasant Street pose with their teacher, Miss Carrie Hammond (back row, far right). Miss Hammond taught from 1873 to 1914. The students are, from left to right, as follows: (front row) Charles Vary, Charlotte Taylor, Molly O'Connor, Etta Holland, Lois Taylor, and George Johnson; (middle row) Alcott Penald, Joe Deveney, Herbert Wilson, Arthur Robertson, John Crocker, Edward Rooney, Thomas Kane, and John Coyne; (back row) May Webster, Sylvia Johnson, Lilly Phillips, Marion Covell, Agnes Holland, and Winnie Mitchell.

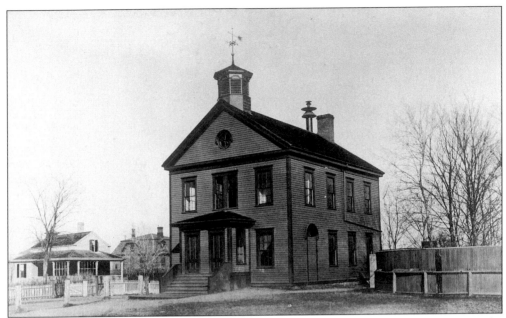

Pictured here is the old schoolhouse on Pleasant Street. Dedicated on September 16, 1851, the two-story building had two entrances with separate stairways and coatrooms for boys and girls. Until 1868, when the town hall was built, only the upper floor was a schoolroom, with the first floor functioning as an assembly room. Note the cupola, which, according to historian Fred Wilson, contained the old bell made by the Revere Copper and Brass Company for the 1818–19 "Old Stone Schoolhouse" formerly located on this site.

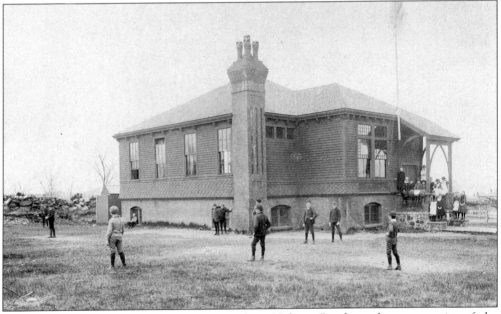

In 1883 a grammar schoolhouse was erected on Nahant Road on the present site of the Ellingwood Chapel in Greenlawn Cemetery. Girl students pose for the photographer while the boys are engrossed in a game. When the Valley Road School opened in 1905 and absorbed the grammar school, the building was converted into the police station between 1906 and 1908.

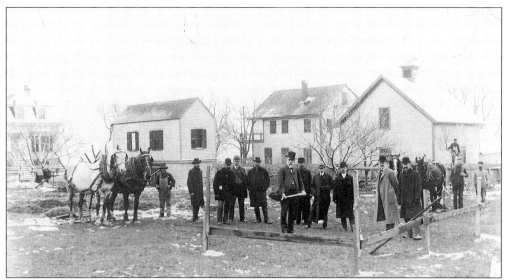

J.T. Wilson (pictured in the center with the shovel), longtime chairman of the school committee, breaks ground for the Valley Road School, which was completed in 1905. The house on the left was the residence of Charles E. Gove. The building third from the left was known as the Henry Dunham house and at the far right is the Dunham Stable.

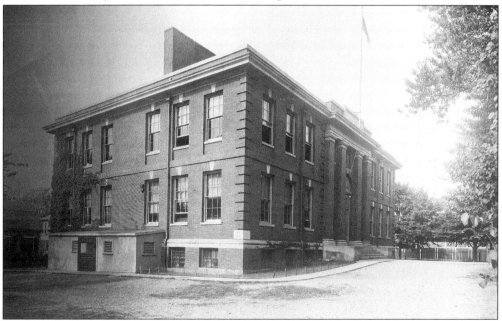

The Valley Road School was built in 1904–1905 at a time when the town's population was growing rapidly (it jumped from 637 in 1885 to 922 in 1910). Neo-Classical-style school held all grades, and was built by the Boston architectural firm of Little and Brown in an area where the Nahant Land Company was rapidly building modest homes. In 1914 the town, at a special town meeting, voted to send its high school students to Lynn. The school remained in operation until the 1980s. Although the building is still owned by the town under the direction of the Nahant Historical Commission, it has been leased to the Nahant Preservation Trust to be developed as a community center.

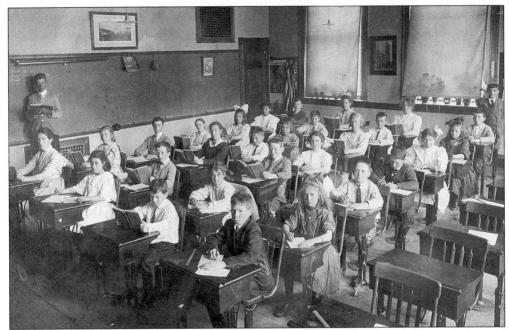

Intent students take a moment from reading and writing to pose for a photographer, c. 1909, at the Valley Road School.

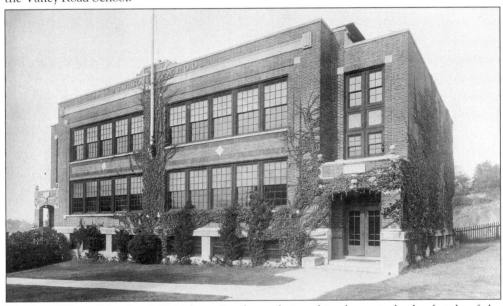

The J.T Wilson School at 198 Nahant Road was designed in the typical school style of the 1910s and was constructed in 1916. The school was named for J.T. Wilson, who for many years served the town in a variety of elected positions, including as school committee chairman. A memorial bronze tablet honoring Wilson at the town hall contains the following lines penned by Senator Henry Cabot Lodge: "An able, upright and fearless public servant. A high-minded, public-spirited citizen." The Wilson School housed the third to sixth grades, leaving the other grades, including the junior high, at the Valley Road School. In the 1980s the building was added to and converted into senior housing, and is called "Spindrift."

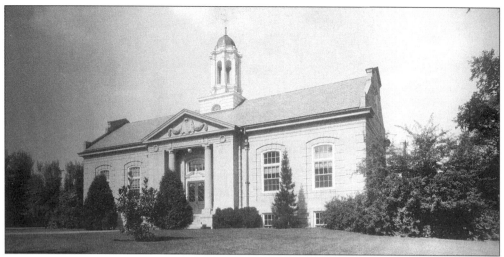

Town Meetings in New England can be contentious and Nahant's have been no exception. The "Battle of Nahant" erupted over building a new town hall in 1911. Although a special committee was established to look into the construction of a new building, a public-spirited individual, Daniel G. Finnerty, took it upon himself to do the same. Mr. Finnerty's plan, estimated at $80,000, was surprisingly accepted at a town meeting. Second thought, though, was given to what was believed to be an underestimate. At a special town meeting on August 8, 1911, Mr. Finnerty's plan was thrown out even though he had lobbied hard, sponsoring a mass meeting with a brass band the evening before to promote it. Architects Robert Andrews, Andrews, Jacques, and Rantoul were hired to work on the building, which was completed at a cost of $92,000. A dedication ceremony was held on November 9, 1912.

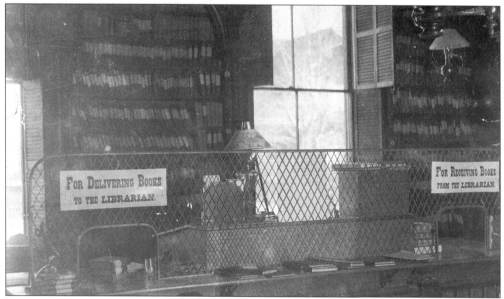

This is a rare photograph of the Nahant Public Library as it appeared when it was located in the old town hall building. Opened on February 12, 1872, the library was expanded due to overcrowding by adding a one-story ell in 1879. Later a second-floor room became available and was used for library purposes. The main room was only 20 by 30 feet and remained in operation until 1895, when the library moved to its present location.

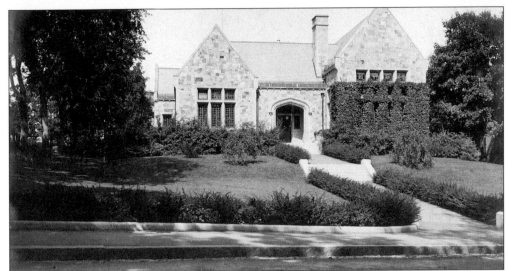

On May 14, 1894, ground was broken for a new library, the planning of which began in 1888 when the town report stated the following: "We hope . . . to erect a fire-proof building, one that will be an ornament to the town and will contain all the rooms and conveniences that a first class library requires." Originally the building contained town offices for the selectmen and town clerk. Architects Ball and Dabney of Boston were hired and certainly fulfilled the hopes expressed in the town report. The stone building is made of Weymouth steam-faced granite with trimmings of Ohio sandstone and a green slate roof. The interior rooms are finished in dark cypress except for the quartered oak reading room (pictured below). The chandeliers were made by Shreve, Crump, and Low. The building and furnishings cost roughly $50,000. Today the building, recently restored, is listed on the National Register of Historic Places. (Courtesy Lynn Museum.)

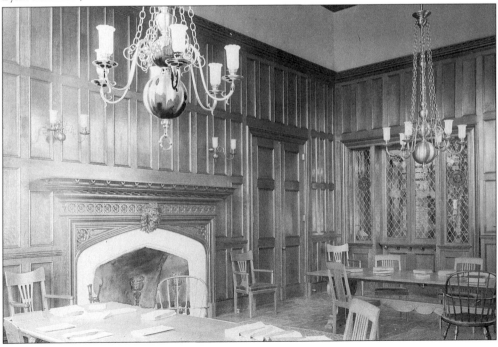

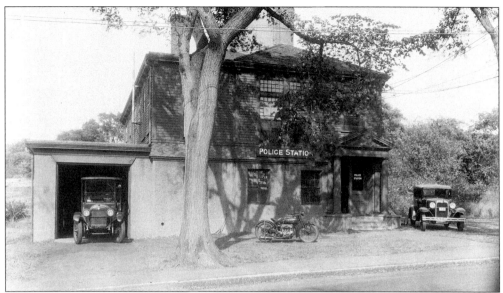

The police station is a "much altered example of a small, shingle-style school." Originally the town's grammar school, the building was converted to a police station between 1906 and 1908. Later the building was moved to 198 Nahant Road, across the street from its original location. In this early 1930s photograph the added ambulance bay is visible with the ambulance parked in it on the left. The police car is on the right. Motorcycles began being used by the department in 1921. Notice the standpipe (water reservoir) looming in the background.

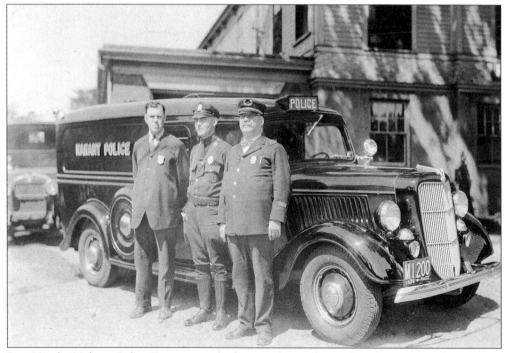

By 1931 the Nahant Police Department had grown from a force of one in 1878 to nine. George Burnett (left), John D. O'Connor (center), and Chief Larkin pose at the police station on Nahant Road with the new 1936 ambulance. (Courtesy Paul Wilson.)

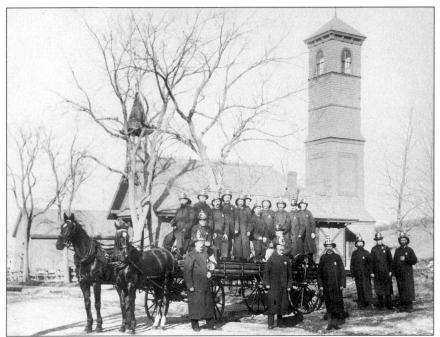

Members of the Nahant Hook and Ladder Company, all call-men, proudly pose for a photographer at the turn of the century. In 1895–96, the fire department consisted of the Board of Engineers, Babcock Chemical Number One, Relief Hook and Ladder Number One, Dexter Hose Number One, Alert Hose Number Two, and Nathan Mower Hose Number Three. The men pose in front of the "Truck House" built in 1878 on Nahant Road at the corner of High Street. The tall tower for drying hoses was added in 1880. The bell, which hung in the belfry shown here, is presently located at the town hall. Take note of the fire trumpet being held by the man standing on the right. This was used to shout orders to the men during a fire. The man sitting with the dog is William Gallery.

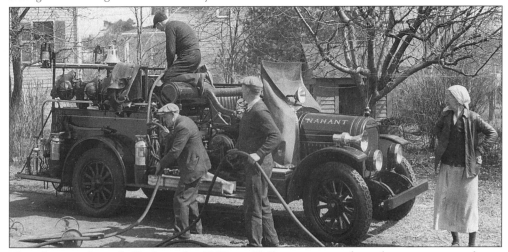

This photograph, probably from the 1930s or 1940s, appears to show the response to a fire at 105 Flash Road. Standing on the ground, preparing to deal with the "Flash" fire, are J. Frank Taylor, a member of the Board of Engineers of the fire department who would later become the assistant fire chief, and Charles Gallery.

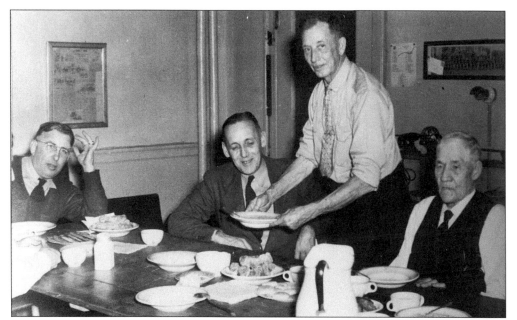

In this early 1950s photograph, fire fighter Dewey Dow serves a group of friends who dropped by for dinner, including Stacy Goodell, Royal Wilson, Dewey Dow, and Lyman Waite, Nahant's first permanent fire fighter. This photograph was taken at the Flash Road Firehouse, which was acquired from the U.S. Army after World War II.

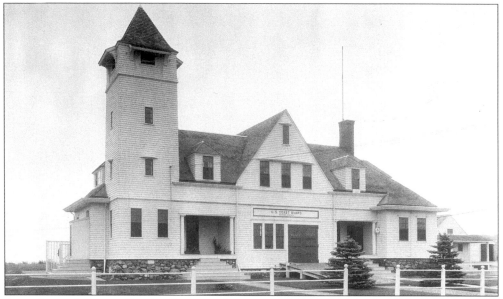

According to historian Stanley Paterson, the waters off Nahant have been the site of a number of shipwrecks, and many people felt that a professional life saving station should be established. With the assistance of Senator Lodge, a life saving station, later the U.S. Coast Guard Station, was completed at 96 Nahant Road in 1900. At that time the crew consisted of a captain and six surf-men. This Queen Anne-style building eventually replaced the volunteer Massachusetts Humane Society boathouse on Curlew Beach. Ownership of the building was transferred to Nahant in 1999.

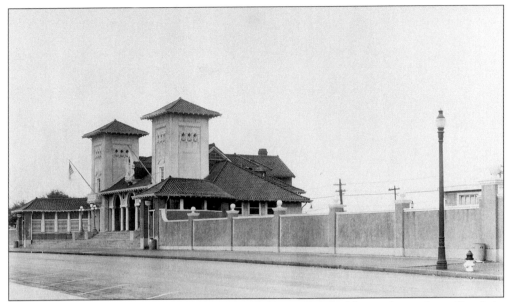

The Metropolitan District Commission opened their stylish bathhouse facing Lynn Beach in July 1905 as transportation improved and the Lynn/Nahant Beaches grew in popularity. The bathhouse had changing rooms for 300 men and 215 women and an emergency room with an attendant and a doctor on call. Sex-segregated tunnels allowed bathers to go back and forth from the bathhouse without crossing the road.

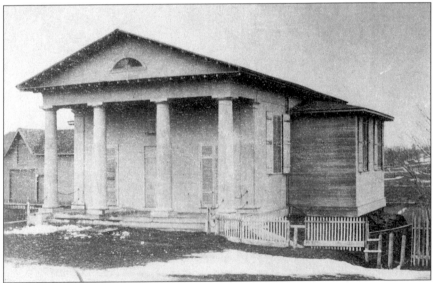

The first church at Nahant, the Nahant Church, was built by summer residents, known as the "Boston people." Constructed in the then-popular Greek Revival style, the building was designed by Boston architect Isaiah Rogers. According to historian Stanley Paterson, "ministers from all segments of Protestantism would be asked to preach in rotation." In 1846, the church was enlarged by adding two wings, one which can be seen on the right of this image. Damaged in a winter gale of 1862, the church remained in use until 1868, at which time the two wings were brought to 370 Nahant Road and pushed together to form a house for Elbridge Gerry Hood.

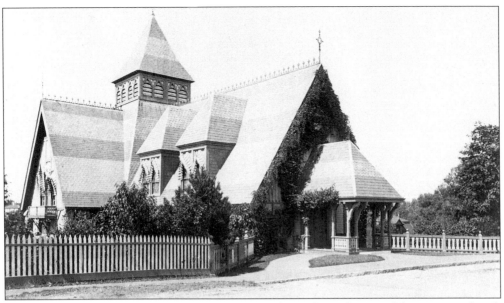

This Nahant Church was built in the Victorian Gothic style on the site of the previous church on Cliff Street by Boston architects William K. Ware and H. Van Brunt, who designed Memorial Hall at Harvard University and St. Stephen's Episcopal Church in Lynn. It was dedicated on June 27, 1869.

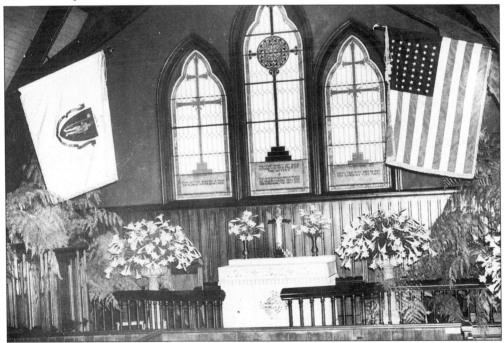

The elaborate chancel of the Nahant Church was further embellished with lilies, greenery, and flags for the Roosevelt-Clark wedding of June 18, 1938. Notice the brass plates at the end of the pew on the right. These plates contained the names of the pew holders who supported the parish with "pew rent." At the time of this photograph the "Boston" Church, as it was known, was still the domain of summer residents.

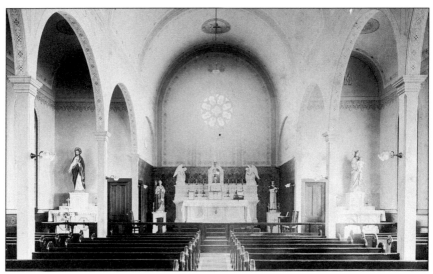

The interior of the original St. Thomas Aquinas Church is shown here as it appeared before the turn of the century. The church was built in 1872, with its tower added two years later, to accommodate the growing Irish Catholic population, particularly summer visitors and servants of summer residents. Masses were held only in the summer until 1902. Originally a mission from Lynn, by 1902 the population had grown so that a separate parish capable of supporting a priest year-round came into being.

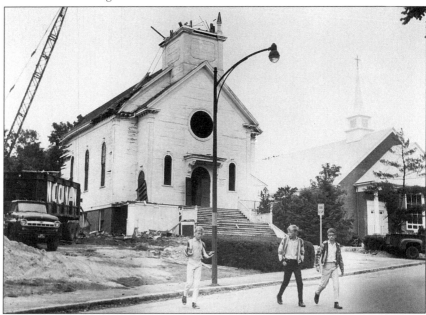

"Out with the old and in with the new" could be the title for this photograph from September 1966. By the mid-20th century, the old St. Thomas Aquinas Church was inadequate, even though it had been raised and a functional basement had been added in 1901. Looking closely, one of the four small pinnacles can still be seen on the steeple. One of these was rescued and is proudly displayed on the garage of the house located at 181 Nahant Road. The new building is shown here in the final stages of construction. The young boys are, from left to right, David and Ken Oxton and Brad Smith.

The original Village Church, built in 1851, served year-round town residents and was located on Nahant Road. By a ballot of residents it was determined that the church would operate as the Independent Methodist Society. This photograph shows the belfry and clock added by the town after a warrant passed in 1872. The tower, bell, and clock were maintained for years by the town and were landmarks. Nahant Historical Society curator Calantha Sears remembers the bell ringing at 11:50 a.m. for dinner, at 5 p.m. to end the work day, and at 8:45 p.m. as curfew for children. By 1957 the church merged with the Nahant Church, and services were held in both locations until 1967, when this building was sold to the YMCA for one dollar. (Courtesy Paul Wilson.)

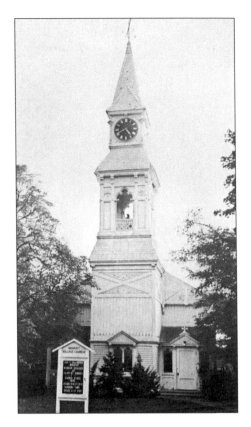

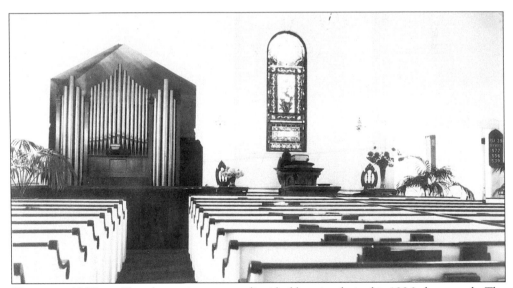

The original Village Church interior appears dignified but simple in this 1926 photograph. The pipe-organ installed in 1907 was eventually replaced by a much smaller organ. In 1968, after the Village Church had combined with the Nahant Church, the pews, organ, and the stained-glass windows of the Village Church were installed in a new chapel at the Nahant Church on Cliff Street.

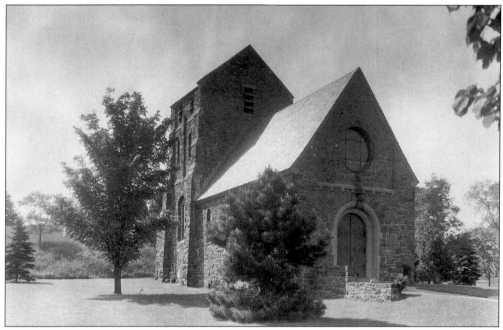

Well-known architect Ralph Adams Cram designed the simple but elegant Ellingwood Chapel in Greenlawn Cemetery in the Norman style. Mrs. Luther Johnson gave the funds to build the chapel in 1918–19 in memory of her husband's parents, Joanne Ellingwood Green and Joseph Johnson Jr. Nahant stone, quarried from the cliffs behind the present Spindrift Apartments, was used in the construction.

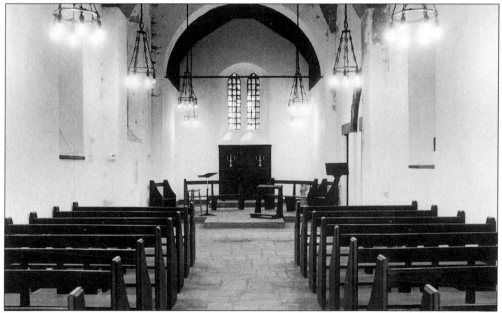

By 1998 the town, through a number of private sources, had completed restoration of the Ellingwood Chapel, including the stained-glass windows made by Connick Studios of Boston. This 1995 photograph showing peeling paint and water-stains clearly indicates the problems the building faced at that time. (Courtesy *Lynn Daily Evening Item.*)

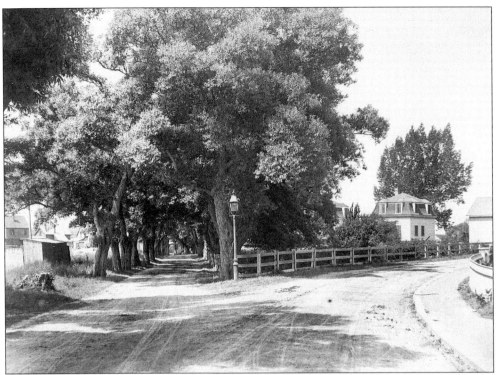

Two views of the junction of Willow and Valley Roads show the changes that have transpired over time. The top view from the 1890s shows that the name Willow Road aptly described the area. By the date of the bottom view, 1910, the area had lost its famed willows. The trolley tracks can be clearly seen running along Willow Road. (Courtesy Lynn Museum.)

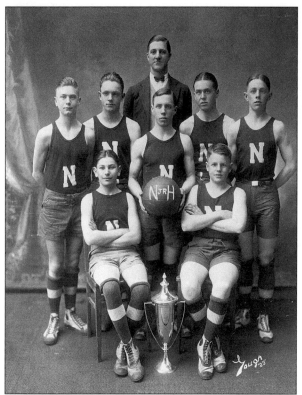

The members of the 1923 Nahant Junior High Basketball Team pose with their winning trophy. From left to right are as follows: (seated) Lawrence Shiller and Donald "Bud" Lewis; (standing) Roy Low, Gustave Rhody Jr., Kenneth Taylor, John Mitchell, and Richard "Dick" Smith. Coach Hoyt Mahan stands in the back.

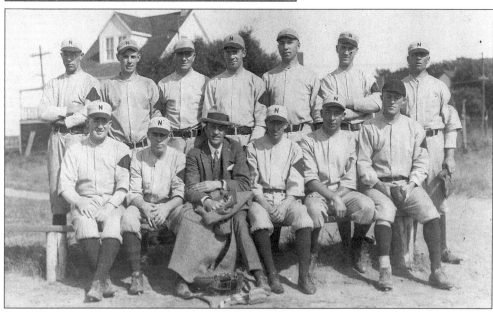

The Village Church sponsored this baseball team for the summer season of 1923. Shown here at the Lowlands Playground are the following, from left to right: (seated) Mayland Lewis (later Judge Lewis), Ken Taylor, Ollie Olsen, Ray Dussault, former police chief Ben Lamphier, and Phil Roland; (standing) Ralph January, Ray Martin, Dick Walton, Micky Lewis, Rev. Dwight Beck, Frank Caffrey, and Ernie Coles.

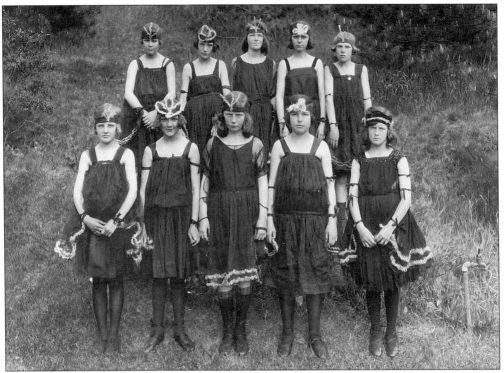

Some frowns and smiles can be detected among the students of Miss Flora Richmond's music class in the 1930s. Here her Valley Road students appear in costume for a performance of *Cantata* to be held at the town hall. They are, from left to right, as follows: (front row) Beatrice Dolliver, Helen Coles, Patricia Larkin, Eleanor Mitchell, and Ellen Harding; (back row) Pearl Kollock, Mary Cherby, Mary Kane, Frances Cusick, and Ruth Gove.

Many of the Irish settlers came to Nahant after the 1840s and lived in an area on Nahant Road known as Irishtown. By 1935, the date of this photograph, the Irish were living throughout the town and the Italians had concentrated in this area. Among the buildings shown here are Seaside Lunch (second from the left) and the Sea Shore restaurant (fourth from the left).

A nice retreat from the beach for these three young girls in the summer of 1934 was the Nahant Playground across from Short Beach. Jane Clune is the young girl on the right. She appears to be enjoying herself along with two friends.

Flower shows at the town hall sponsored by the Nahant Garden Club were popular summer season events. The garden club also held teas and classes for children on the grounds of the town hall, according to Historical Society Curator Calantha Sears. In 1944 Roz Butler Puleo, age one and a half, and Sue Bushnell, age three years, appear perplexed to be part of the flower arrangement. (Courtesy Roz Butler Puleo.)

Six
NAHANTERS AT WORK

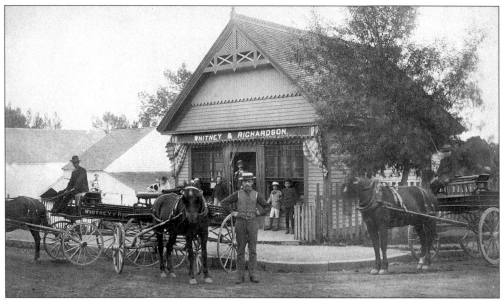

Whitney and Richardson's store, on the corner of Wharf Street and Nahant Road, was photographed in the 1880s, possibly when the shop just opened. The building was done in the current Stick style with a gabled roof, decorative trusses in the gable, wide overhanging eaves, and a picket fence pattern across the gable end. Note the white barns of the Whitney Hotel stables in the background. The building still stands as a private house.

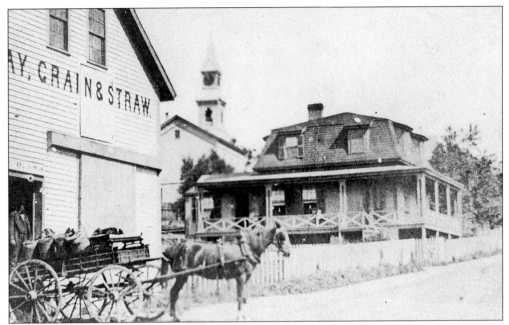

In the mid-1870s H. Shepard Johnson, a member of the old Johnson family, operated a hay, grain, and straw business on Summer Street. For a short time hay was landed at Tudor Wharf. Active in the town, he served on the board of library trustees and the school committee. Note the Village Church steeple in the background.

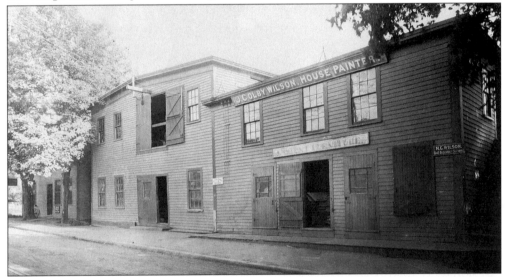

One of Nahant's main industries in the 19th century was the building business of Joseph T. Wilson and Sons, Inc. The business, founded in 1868, was located on Spring Road and had another office in Beverly Farms. It has been estimated that the firm built, remodeled, and in some cases, moved a total of 164 houses, stores, stables, greenhouses, and cottages on Nahant between 1868 and 1900. J.T. Wilson also specialized in making, repairing, and upholstering furniture. J. Colby Wilson, brother of J.T., operated the painting branch of the business on the second floor of his brother's building. The structures shown here in the 1890s were taken down in 1951. (Courtesy Paul Wilson.)

In the 1890s and into the first decade of the 20th century, James C. Shaughnessy was one of a handful of plumbers in town. Shaughnessy advertised as a "plumber and tinsmith, manufacturer of tin, sheet iron, and copper-ware stoves as well a dealer in stoves, ranges, furnaces, and kitchen furnishing goods." This was in addition to "sanitary plumbing, drainage, and ventilation." This building at 54 Pond Street moved from the Short Beach area and was used as his shop for many years. Now extensively remodeled, it is a private home.

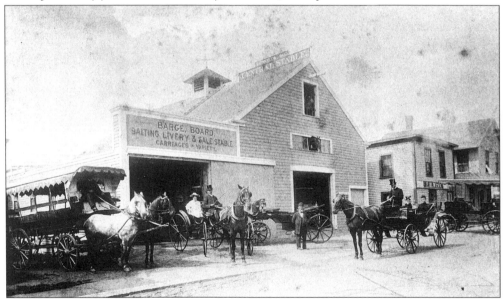

Byron Goodell began transporting passengers by horse-drawn barges from Lynn to Nahant in 1867. By the 1890s, when this photograph was taken at his Summer Street stable near Willow Road, his sons, Charles B., Arthur S., and Herbert L. Goodell, had joined him in the expanded enterprise, which began offering livery and boarding services. One of Goodell's White Line barges is visible on the far left.

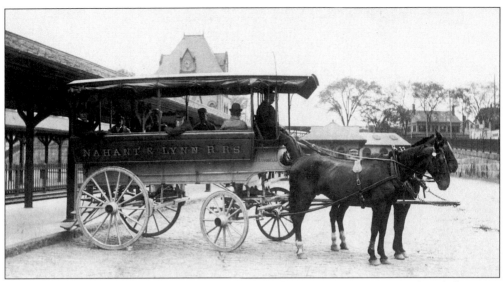

After the Civil War, Byron Goodell began service between Whitney's Hotel and the Lynn B&M Central Depot known as the White Line of Barges, which transferred passengers between the two sites. The line was in operation until 1906, when the first electric trolleys came to Nahant. The driver in this image is Arthur S. Goodell. The line also offered beach-wagons, coupe and other carryalls, and "buggies furnished at short notice." (Courtesy Lynn Museum.)

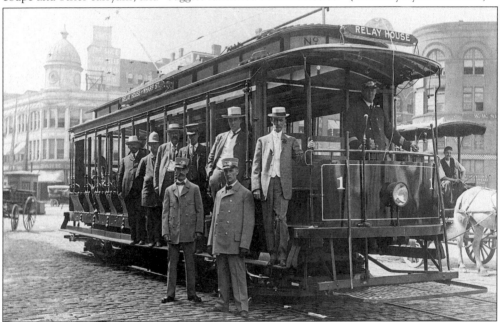

Beginning in 1861, Nahant Town Meetings had considered a street railway but it was not until 1903 that the town voted in favor of one. The Nahant and Lynn Street Railway was opened for regular traffic on July 20, 1905, and ran until 1930. The automobile is credited with the demise of the service. Here the crew and passengers are photographed in Central Square, Lynn, c. 1905, before departing for the Relay House and Bass Point. Notice the horse-drawn barge to the right. This earlier service to Nahant had, in turn, been put out of business by the street railway. (Courtesy William Conway.)

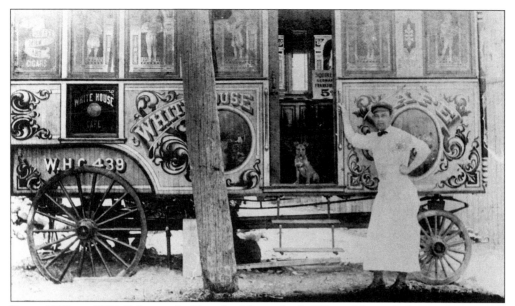

From 1892 to 1910 Ephraim L. Hamel of Lynn built White Horse Café Lunch Wagons, forerunners of the diner. This wagon at Bass Point Road near the Midway was typical of the cafés as it was 16 feet long, painted white, and embellished with etched glass windows. (Courtesy Larry Cultrera.)

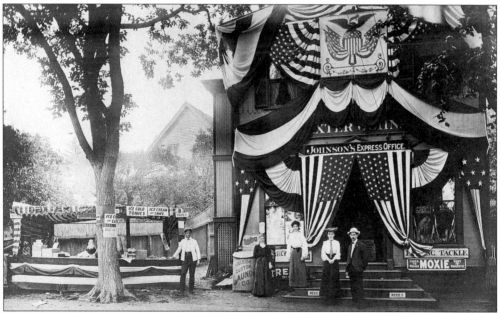

T. Dexter Johnson's Variety Store was located on Nahant Road near Summer Street and had a "specialty of fine butter." His advertisement in the Lynn Suburban Directory also listed "choice family groceries, gents furnishings, druggists sundries, and Yankee notions." Moxie seems to be the drink of choice in this 1903 photograph. There are at least ten signs urging customers to "learn to drink" "very healthful" Moxie. Johnson was obviously hoping to attract business during the town's 50th anniversary. Besides operating his business, Johnson was a selectman and postmaster.

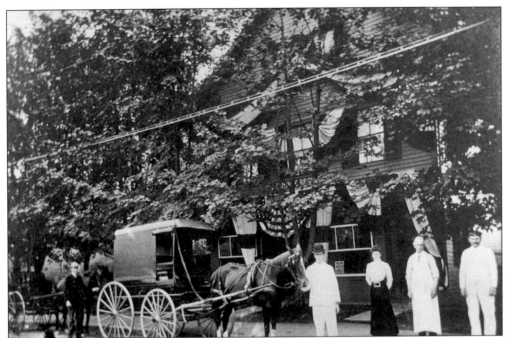

Thomas J. Cusick, fourth from the left, was for many years a clerk in G.E. Poland's grocery store on Nahant Road. By 1902 he opened his own provision store, T.J. Cusick & Sons, on the ground floor of his home at 165 Willow Road, as shown here. This store remained in operation until 1920. Cusick became the town's postmaster in 1899 and served until his death in 1927.

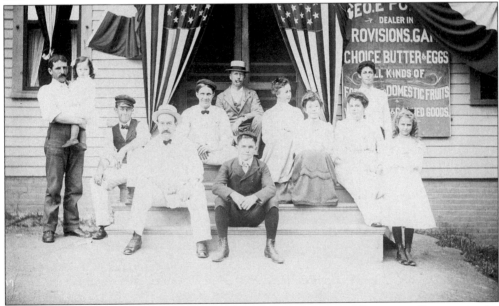

George Poland, the proprietor of George E. Poland's Grocery and Provisions Store, is in the very center of this photograph smoking a cigar. The women to his right are members of the Poland family. This photograph was taken in 1903, when Teddy Roosevelt visited Nahant; only a year before, the store had moved to its location on Nahant Road near Pleasant Street in the post office block. The store closed in 1917 due to declining business.

When this photograph was taken in the 1920s, New England Telephone and Telegraph operated in two area locations. In Nahant the company was located at 18 Valley Road from 1912 to 1960, and in Lynn it was located at 486 Central Square. The Nahant location is now a private home. Nahanters enjoyed the personalized service. It was possible to call the operator and ask them to forward one's calls to another person's house while visiting, which the operator graciously would do.

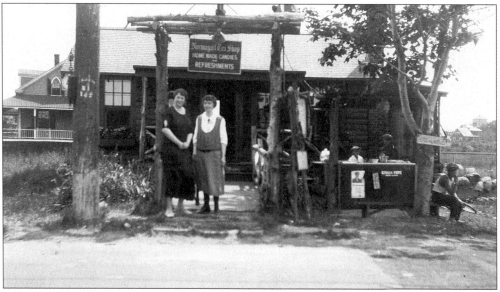

Nahant was home to at least two tearooms in the 1920s, when this photograph of the Normagail Tearoom (later the Log Cabin) at the corner of Spring and Nahant Roads was taken. The tearooms catered to summer residents and visitors, offering homemade refreshments. Mrs. Brown and Reba Thompson, a summer employee at the tearoom, are shown posing out front. Reba Thompson met and married a Nahanter, Fred L. Timmons. On the right of the photograph, youngster George Ward sold "tonic."

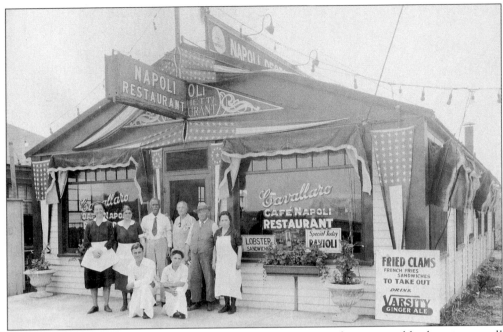

Owned by the Cavallaro family, the Napoli Restaurant was four years old when it was all festooned for the 75th anniversary of the town in 1928. Located on Nahant Road, the building was raised and has seen a number of different business uses including Frank and Sam's. Shown here are, from left to right, as follows: (kneeling) Joseph DiClerico, and Frank Cavallaro; (standing) waitresses Minnie and Rose, Mr. and Mrs. Angie Moligia, Frank DiGrazia, and his daughter, Mrs. Cavallaro.

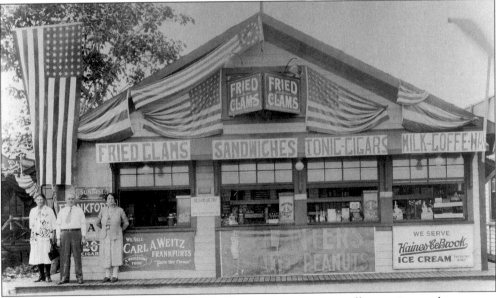

Many of Nahant's lunch stands and some restaurants were seasonally catering to the summer visitors to the beach or Bass Point. This photograph, taken during the 75th anniversary of the town in 1928, shows Bigny's stand on Nahant Road, near Spring Road. To the left is the Normagail Tearoom.

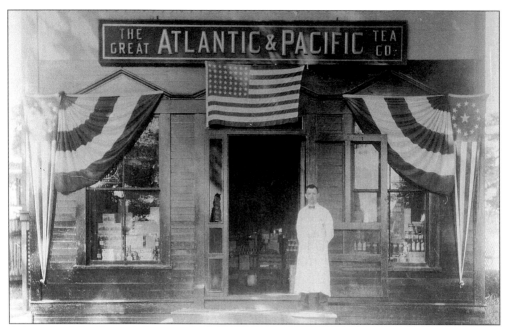

A branch of the Great Atlantic and Pacific Tea Company (popularly known as the A&P) was located at 302 Nahant Road. The grocery did business in the town in the late 1920s but was gone by 1942. In 1928, when this photograph was taken, manager Harry Duggin posed in front of the store.

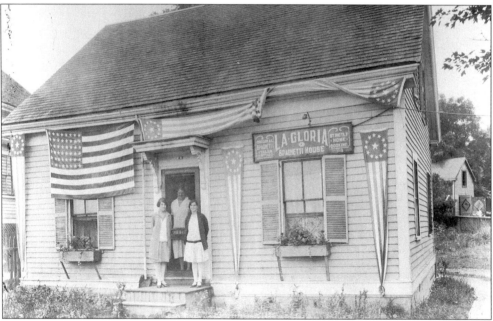

La Gloria Spaghetti House, according to the labels on the photograph, was located at 151 Nahant Road. This area, known as Irishtown, was increasingly becoming home to Italians, many of whom, like the Cavallaros, operated restaurants. According to Nahant Historical Society Curator Calantha Sears, "people came from all around for spaghetti." Mrs. Bongiorno, whose family owned the restaurant, is standing in the doorway.

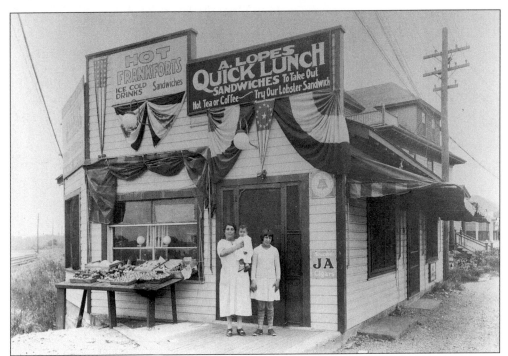

In 1928, Antonio Lopes and his wife, Mariana, owned a variety store at 2 Castle Road. This shop, adjacent to the Lopes' home, was run seasonally, offering a quick lunch as well as fresh produce. Mr. Lopes was also a fisherman, insuring fresh lobster sandwiches. In later years the store was operated as the Nahant Pharmacy.

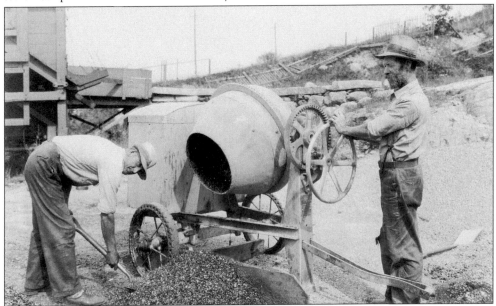

The photographer of this 1930 image captured the operators of a mixer at the town pit located on Greystone Road, set back from Nahant Road. It was here that the highway department had its headquarters. In the left background a portion of the stone crusher can be seen. Patrick John Devency is on the right.

John Henry Humphrey was a well-known Nahant letter carrier who served 22 years, from 1925 and 1947. In this 1938 photograph he seems to be enjoying his work. Mail carrier service first began in Nahant in 1901, when the Nahant Post Office became a branch of Lynn's. Beginning in 1847 residents collected mail from their own boxes in the Johnson family grocery store on Nahant Road. The year carrier service began, the post office moved to the Johnson Block on Nahant Road.

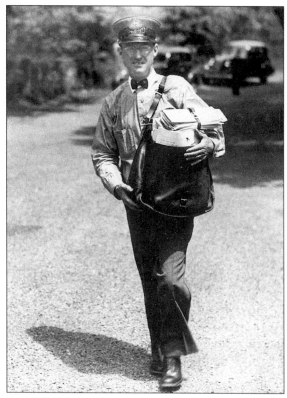

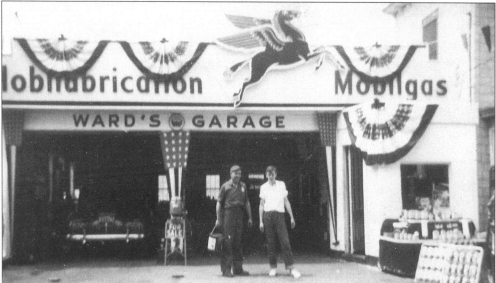

In the early part of the 20th century P.J. O'Connor, a prominent contractor and longtime town highway surveyor, erected this building to house the horses, wagons, and later trucks used in his business. In 1946 George Ward bought the building, modernized it, and offered the townspeople expert auto repairs as well as gasoline. He is shown here with his son, George Jr., at the time of the town's 100th anniversary celebration in 1953. George retired in 1966, and now Frank Barile continues the tradition of fine service at this site under the name of Enzo's Garage.

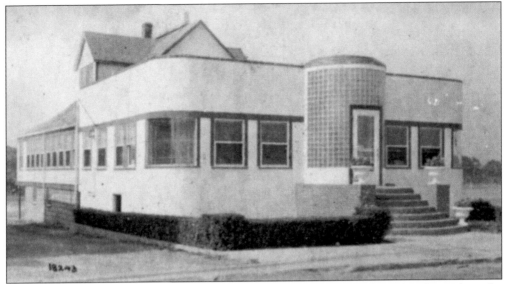

This art-deco influenced building, the Four Hundred Club at 139 Nahant Road, stood out for its distinctive architectural style. Owned and operated by the Cavallaro family, the year-round restaurant specialized in Italian food. The restaurant was particularly popular during the war years with both the town residents and the military.

When this photograph was taken in the early 1960s, local historian Charles C. Gallery had been a master plumber for over 40 years. His father, William Gallery, preceded him at the 54 Pond Street shop, which originally began with J.C. Shaughnessy in 1884. A profile in *The Boston Globe* of May, 17 1962, perfectly described the situation shown here as "well regulated disorder."

Seven
A TOWN CELEBRATES

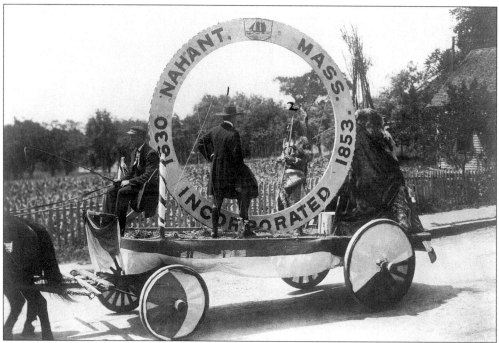

In 1903, Nahant celebrated its 50th anniversary as a town. Historian Fred Wilson wrote, "The grand parade was an impressive scene." The parade covered the town, starting and ending on Winter Street. Here a tableau vivant float of the first Nahant Town Seal makes its way along the parade route.

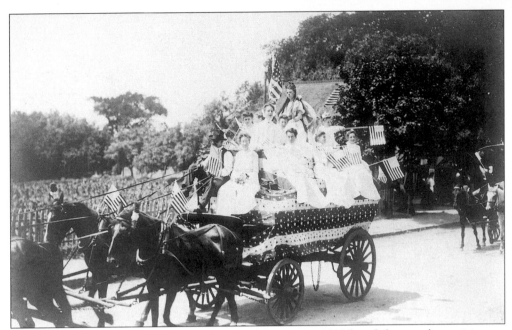

The official program of the semi-centennial celebration in 1903 listed the parade participants, which included town officers, GAR veterans, the Lynn Cadet Band, the school department, teachers and students, and the entire fire, highway, forester's, health, and street lighting departments. Several floats were included, including a wagon of "Nahant girls."

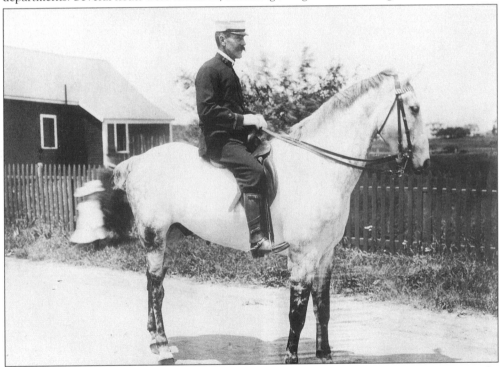

Samuel Hammond, a longtime summer resident, was a member of the organizing committee for the celebration and was chief marshal of the parade.

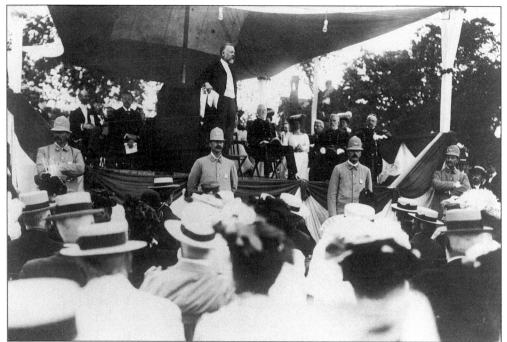

The 50th anniversary of the incorporation of Nahant on July 12, 13, and 14, 1903, was one of the biggest celebrations in the history of the town. Several speeches commenced at 3 p.m. on the grounds of the Nahant Club. Standing on the stage, Senator Henry Cabot Lodge is shown here delivering his remarks. The other speakers were J.T. Wilson, chairman of the selectmen, John L. Bates, governor of Massachusetts, and Curtis Guild Jr., lieutenant governor of Massachusetts.

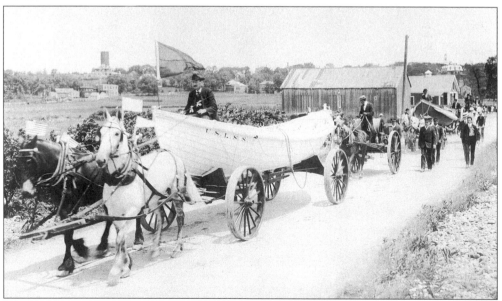

Members of both the Nahant Life Saving Crew and the Massachusetts Humane Society Lifeboat Crew marched in the parade. This view shows the parade traveling along Willow Road.

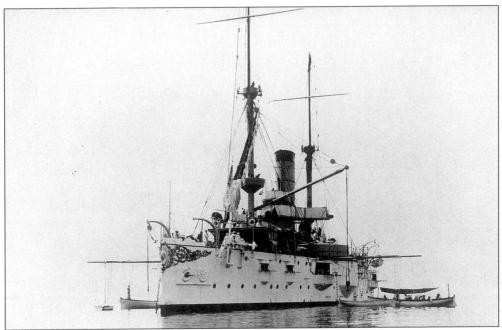

As part of the festivities on July 13 and 14, eight warships of the U.S. Navy were open to the public in the morning and afternoon. Visitors could view the ships by boarding a boat from Tudor Wharf. The vessels included a second class battleship, the USS *Texas*, the flagship of Rear Admiral James H. Sands; a first class battleship, the USS *Indiana*; a training ship, the *Hartford*; and five torpedo boat destroyers: the USS *Decatur, Dale, Barry, Chauncy,* and *Bainbridge*. The squadron participated in the parade and band concert as well as in water sport competitions.

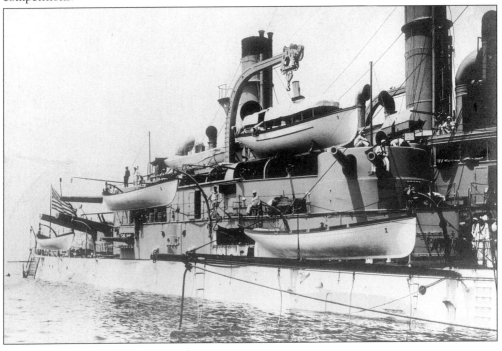

Over the years Nahant has played host to many dignitaries. In August 1902, President Theodore Roosevelt spent an evening with his best friend, Henry Cabot Lodge. It was in Nahant that President Roosevelt began a speaking tour, the next day giving a patriotic speech in front of the public library to hordes of well-wishers. Selectman J.T. Wilson, to the right of the President, made the introduction.

Memorial Day, May 30, 1910, was celebrated in Greenlawn Cemetery with a ceremony at the Civil War Soldiers Monument, which was erected in 1866. Members of the Grand Army of the Republic, probably from Lynn's Post Five, can clearly be seen in uniform. Many Nahant veterans belonged to the Lynn Post. Greenlawn Cemetery was established in 1858 on land the town had purchased two years previously. Several additions of land have brought the cemetery to its present size.

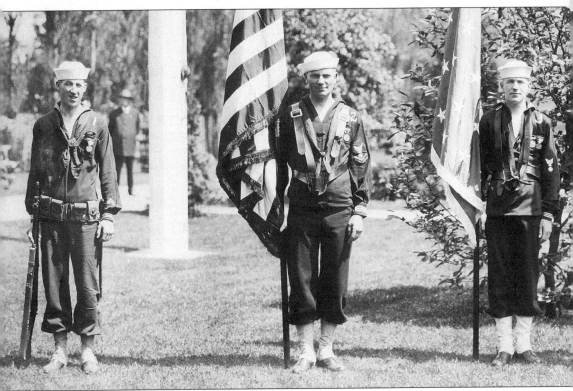

The color detail of the Mortimer G. Robbins' Post of the American Legion pose for a photographer outside the new town hall on Memorial Day. The post was named for the first Nahant man killed in the fall of 1917 during World War I. The flags shown here were given by

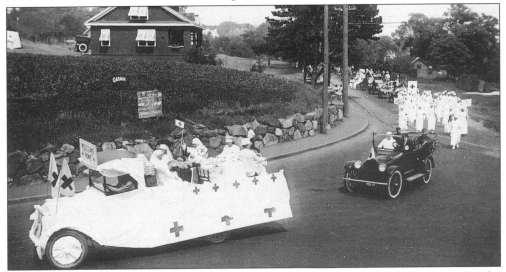

A huge celebration welcomed home Nahant volunteers at the end of World War I. By 1919 the town report listed 81 residents in military service. On July 4, 1919, after a banquet the previous night and a morning and evening of band concerts, "a parade of the best the town contained" followed, including the Red Cross float shown here at the corner of Spring and Flash Roads. The "Welcome Home" sign is visible above the windshield.

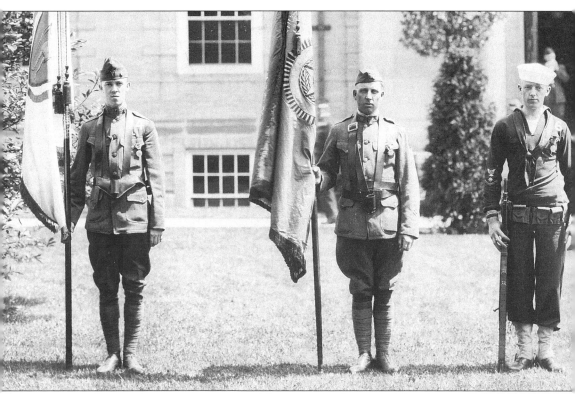

private residents and civic organizations of the town. At the time of the photograph, the post occupied two rooms in the town hall. In 1924 the town gave the old town hall to the group for its usage. (Authors' collection.)

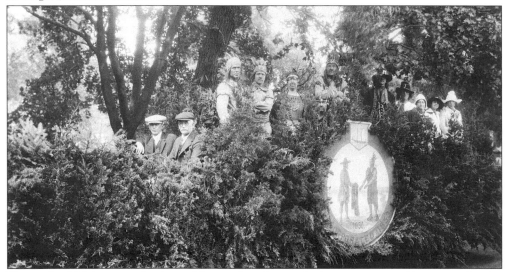

The seal of Nahant is clearly visible on this float, which was sent to Gloucester for the 300th anniversary of that town on August 18, 1923. Driver Earl Dow and Robert Cole pose along with Martin O'Connor, Albert Cheever, Mrs. William Gavin, Lyman Waits, Robert Coles Jr., Mrs. Helen Coles, Miss Ada Coles, and Doris Dow. The float won first prize in the parade.

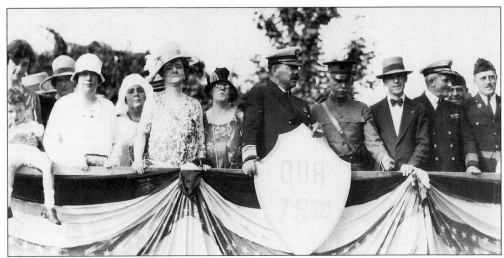

Dignitaries can be seen on the reviewing stand at the Nahant Club for the town's 75th anniversary celebration, July 28, 1928. Vice Admiral M.M. Taylor is standing behind the "Our 75th" sign. To the right is J. Lothrop Motley and Congressman William P. Connery of Lynn. Financial restraints did not allow for as lavish a celebration as the 50th anniversary but the event did include a parade and games.

Stacy Goodell and his wife, Helen, lived in this house at 11 Emerald Road, festooned with bunting and an American flag for the town's anniversary in 1928. A road surveyor, Goodell poses on his front steps with his son Arthur. The family dog can be seen getting into the picture on the backstairs.

Summer residents Mr. and Mrs. Thomas Green of 170 Willow Road pose along with a friend in front of their elaborately decorated home. The house was moved across the street from Boathouse, or Cobbler's, Beach and remodeled from the boathouse of the Massachusetts Humane Society. The volunteer lifesaving organization had stations here and in Swampscott.

These two women may have been taking their lives into their own hands, as well as the lives of any pedestrians for that matter, since the windshield of the car appears to be completely blocked by an oversized butterfly. The float was created by the Nahant Women's Club for the 1928 celebration.

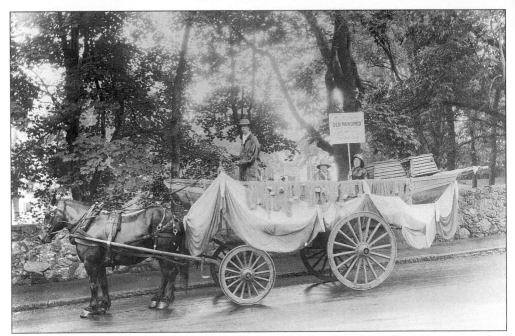

The fishing industry of the town was commemorated by this 1928 float. The 19th-century dory filled with nets and traps belonged to Capt. William Kemp, a master mariner, and his son, Capt. Charles F. Kemp, a dealer in fresh fish and lobsters as well as all kinds of smoked and pickled fish. Charles Kemp was a wharfinger (a man in charge of a wharf) for over 26 years. The driver of the float is George Alexander and the boy holding up the sign is Harold Kemp.

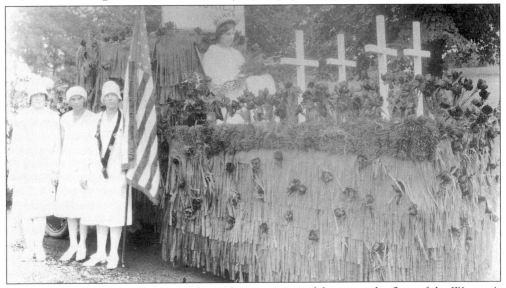

During the 1928 parade celebrating the 75th anniversary of the town, the float of the Women's Auxiliary of the American Legion was awarded an honorable mention. Entitled "Flanders Field," the float recalled our soldiers lost in battle in the Great War. On the float Mrs. Dana Sanborn, a Gold Star Mother of Mortimer G. Robbins, Nahant's first World War I casualty, appears lost in thought. Standing to the left are Mrs. Arthur Timmins, Mrs. Mayland Lewis, and Mrs. Francis Raiche.

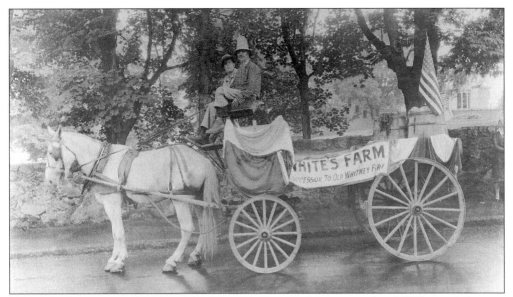

By 1928 White's farm was the only operating farm on Nahant, since the old Whitney's farm on Nahant Road had ceased operation. Drivers Ralph Mitchell (left) and Theodore Cummings posed during the 1928 celebration with their display of the farm's produce. Fred A. Wilson, town historian, wrote that once "many acres were under cultivation on Nahant, and there were fields of grain and considerable yields of vegetables."

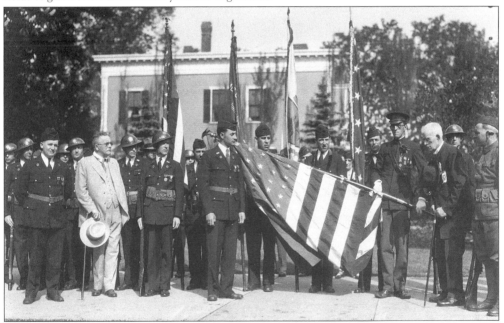

At the conclusion of the Decoration Day Parade on May 30, 1929, the last GAR veteran from Nahant, Augustus A. Barnes (at right in the front row, holding a cane), presents a flag to the Spanish-American War veterans and the American Legion Post 215. Also shown in the front row, from left to right, are Lieutenant Mayland P. Lewis, Commander of Post 215; Fred A. Wilson, town moderator; an unidentified man; Leon M. Delano, a town selectman and member of Post 215; and Daniel G. Finnerty, a Spanish-American War veteran holding the flag.

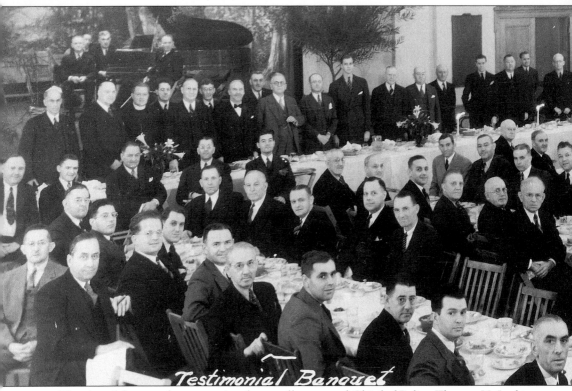

Testimonial Banquet

The size of the crowd attests to just how well-respected Chief of Police Thomas H. Larkin was after 41 years of service. His retirement party of December 29, 1938, at the town hall brought out not only local men, but also state and county police officials. Chief Larkin is visible at

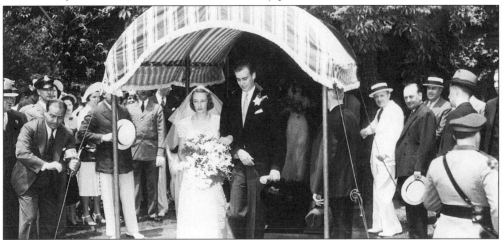

The event of the season was the Anne Clark and John Roosevelt wedding at the Nahant Church on the bright and sunny day of June 18, 1938. A reception followed at the Nahant Club. Of the 800 guests fewer than 300 crowded into the church, although 700 attended the reception. Another 100 people crowded on the curb to catch a glimpse of the couple. The newlyweds resided at the Clark family home on Swallow's Cave Road for a few years, moved to California, and eventually came back to the East Coast. The marriage produced four children but ended in divorce.

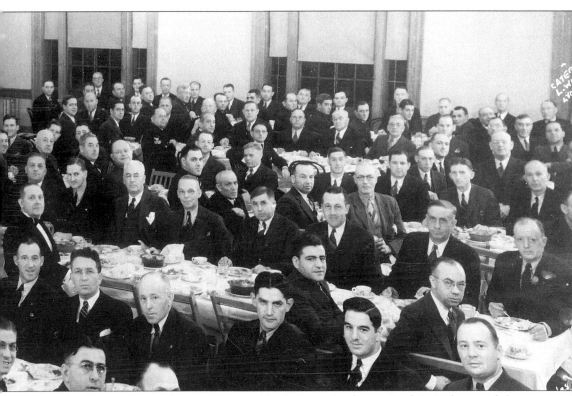

the head table wearing the bow tie. Next to him is Town Moderator Fred A. Wilson, and the tall gentleman is John A. Roosevelt. Larkin joined the force in 1896, became chief in 1904, and remained in that position until his retirement.

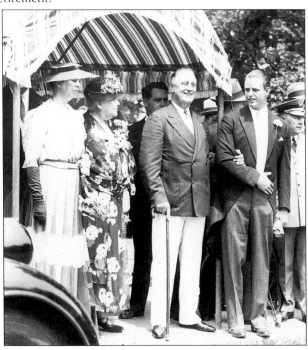

Mrs. Franklin Delano Roosevelt, Mrs. Sara Delano Roosevelt, President Franklin Delano Roosevelt, and Elliot Roosevelt pose for a photograph after the Clark-Roosevelt wedding ceremony. The President had arrived by train in Salem, where he boarded the *Potomac*, the presidential yacht. Huge crowds tried to get a glimpse of him as he was driven to and from Salem.

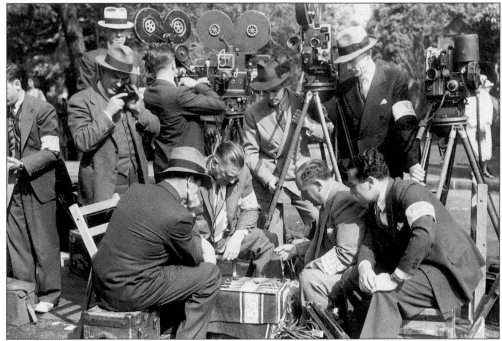

Nahant has probably never seen as much national attention as on the occasion of the Clark-Roosevelt wedding. The press converged on Nahant, setting up in the town hall. According to historian Stanley Paterson, Western Union installed telegraph and telephone lines, and arrangements were made by the newspapers for "those who lived around the church or the Nahant Club for the use of their roofs, their telephones, or both, so they could bring the world a moment-by-moment account." For all the excitement of being a reporter, there is often much down time, and here reporters and photographers had time for a board game.

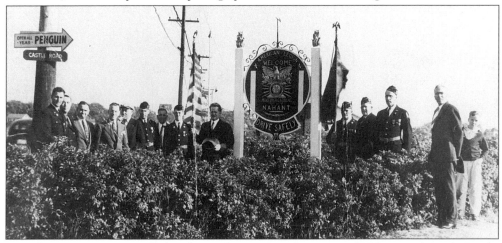

A "welcome" sign was installed in September 1940 at the corner of Nahant and Castle Roads. Members of the Mortimer G. Robbins Post of the American Legion pose in front of the sign they installed. From left to right are Commander Edward Pratt, Alfred Cullis, Raymond D'Arcy, Arthur Timmins, Matthew Athy, William McLaughlin, Ernest Coles, Harold Gould, Mayland Lewis, Arthur Robertson, Harry Lewis, Bradford Hathaway, Edmund Hyde, and Jimmy Hathaway.

Eight

THE BABY
BOOMER YEARS

For many years Patricia Arzillo produced and directed plays in Nahant. People from all over town were involved and everyone seemed to enjoy themselves. The audiences anticipated them every year with great delight. Here is the cast of *You Can't Take It With You*, performed in May 1960 at the town hall. From left to right are as follows: (front row) Joseph Jewett, Betty Macarelli, Vernon Odiorne, Phyllis Serianni, Arthur Fay, Carolyn Fowle, John Durnam, Phyllis Cormier, and Stanley Paterson; (back row) Howland Warren, Wentworth Stone, Louise Titus, Albert Serianni, Bert Jones, Mary Jones, William Dragon, Conover Fitch, Priscilla Fitch, and Norman Wilson. (Courtesy Catsy Fowle.)

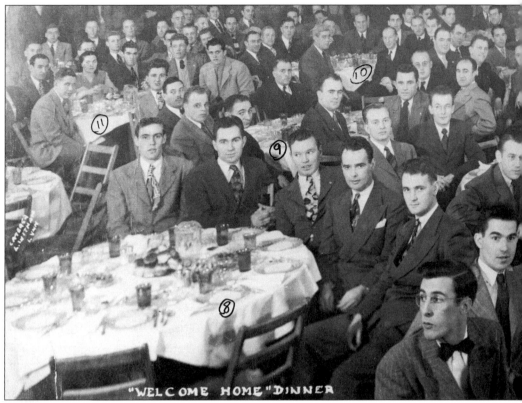

A November 23, 1945 article in *The Boston Daily Globe* began with the headline, "Nahant sent 350 into service. Every fifth person in town went off to war, setting a record few places can match; 12 heroes will never come back." The article goes on to say that this was nearly twice

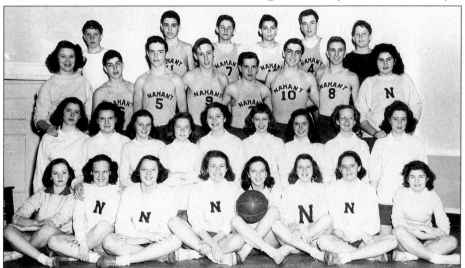

The 1949 Nahant Junior High basketball teams were honored at the town hall during "Community Night." The boys received letters while the girls—Nahant's "dream team"—were awarded blue jackets appropriately inscribed "GREATER BOSTON GIRLS JUNIOR CHAMPIONS."

the normal percentage of men and women showing the patriotism that has served this country so well in all its conflicts. To celebrate those who returned from service in World War II, a huge "Welcome Home" dinner was held at the town hall on December 30, 1946.

Millie and Ray Foote are captured during a romantic moment at Canoe Beach in 1947. The Foote's lived in Fort Covington, NY, and spent summers on Nahant, staying with Millie's sister, Shirley Butler, at 360 Nahant Road. (Courtesy Roz Butler Puleo.)

In July, 1953, Nahant celebrated the centennial of its incorporation as a town with five full days of events. At that time the population of 2,700 year-round residents swelled to 15,000 for the centennial parade. Events included the General Electric Company's "House of Magic" show and a historical pageant "Panorama," on the history of the town. One of the highlights was the Centennial Banquet on the lawn of the Thompson Club, now the Country Club. Henry Cabot

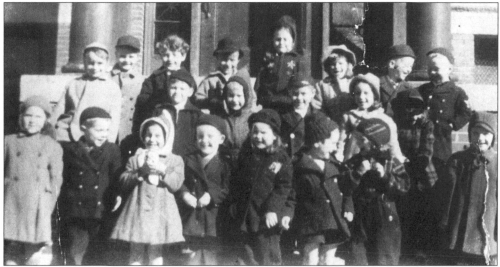

This is the first grade class of the Valley Road School in 1942. Shown here are, from left to right, as follows: (front row) Linda Sterenberg, Paul Bradley, Norma Gove, Charlie Johnson, Carol Evans, Janice Ross, Anita White, and Richard Carey; (middle row) Russell Miller, Robert White, Art Milne, Bruce Ranger, Natalie Sherber, and Lottie Beauchain; (back row) Frank DeGrazio, Johnnie Marsh, George Adolph, Sheila Carey, Thursa Adolph, Pat Phaup, and Cole Gaudet.

Lodge Jr., U.S. representative to the United Nations, was the guest speaker, and can be seen at the head table (below the flagpole) at the top of the photograph. Still more events included band concerts, a "horribles" parade, sailing races, games, and a block dance for teenagers. The climax was the centennial parade. A newspaper report of the day said, "The parade itself had everything."

This is the same class from the previous page, photographed in the same spot nine years later as they prepare to graduate from Nahant Junior High. Although some students had moved away and others had joined the class, many of the faces are the same. They are, from left to right, as follows: (front row) Sandy Hyles, Nancy Elliot, Gail Coles, Lee Erikson, Natalie Sherber, Norma Gove, and Pauline Bonanno; (second row) Betty Sterling, Lottie Beauchaim, Anita White, Carol Evans, Janice Ross, and Johnnie Marsh; (third row) Robert Whyte, Ray Sherber, Ed Spinney, Russell Miller, Mel Kaplan, Jock Bargett, Cole Gaudet, and Art Jacobsen; (back row) Ralph Hughes, Pat Phaup, brothers Billy and Jim "Leo" Coffey, Richard Carey, Arthur Milne, Frank DiGrazio, and Eddie Lovely.

Dan Carey, a plumber, works up a sweat digging out space for his garage in August 1949. His son Bob (George) on the left and daughter Pat lend assistance. Their home, 7 Lafayette Terrace, was built in March 1949 and remained a summerhouse until 1958. Since Lafayette Terrace only went as far as this house, Dan dumped the excavated material further down hill, forming a base for the extension of the road. (Courtesy Bob and Mary Carey.)

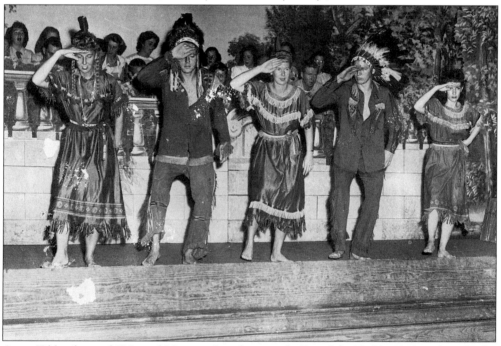

Anne Tibbo directed "Musical Varieties" at the town hall on July 28–29, 1948, to benefit the Nahant Village Church. Alma Lewis (Smith), Ted Sturgewold, Peggy Delaney (Lester), Robert Trimble, and Roselin Hopgood perform in "Dance of the Cherokee." (Courtesy Roz Butler Puleo.)

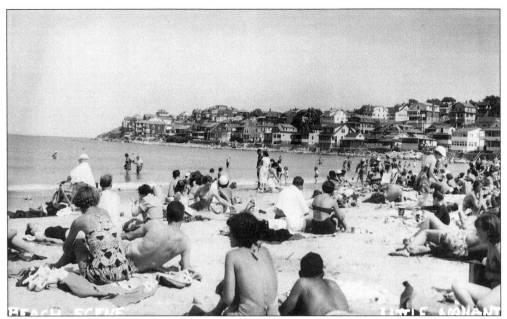

Beach-goers enjoy a summer day in 1952 at the Nahant end of Long Beach. By this time, Little Nahant had become fully and densely developed.

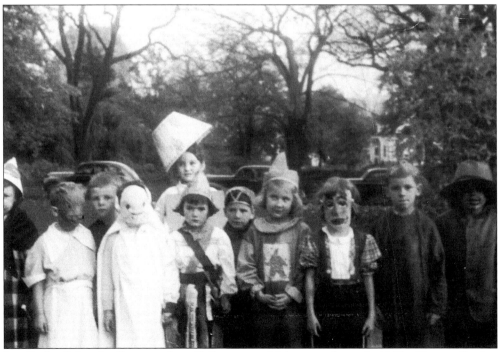

Roz Butler Puleo fondly remembers Halloween in Nahant in the early 1950s. She recalls that "everyone knew each other" and the kids "pretty much covered the whole town." Here youngsters pose at the Pleasant Street Playground. (Courtesy Roz Butler Puleo.)

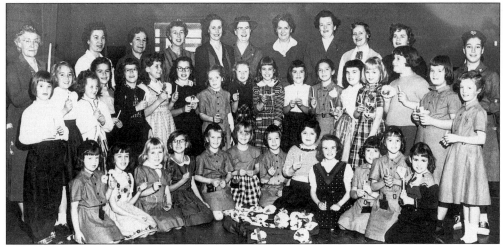

An investiture ceremony took place for the Nahant Brownies of Troops 184, 40, and 140 at the Johnson School in 1955. Shown here are, from left to right, as follows: (front row) Penny Spinazola, Suzanne Cyr, Carol Carmody, Gloria Loguerico, Evelyn Johnson, Judy Larkin, Judy Livingston, Sandra Cavallaro, Susan O'Connor, Leonie Linden, Candance Palmer, and Coleen Marston; (middle row) Martha McDonough, Carol Gates, Eileen Lombard, Mary Lou Morin, Nancy MacDonnell, Kathy Murray, Frances Sciaba, Jean Burns, Jane Kirkman, Kathy Hollingsworth, Harriet Haddon, Ann Barron, Veronica Freyou, Doreen Hefler, Phyllis Litchman, Janet Patten, and Linda O'Connor; (back row) Mrs. Sidney Doane, Mrs. Clayton Gates, Mrs. Spiro Cody, Mrs. Donald Downs, Mrs. Charles Burns, Mrs. John McLeish, Mrs. Richard Gove, Mrs. Leonard MacDonnell, Mrs. Louis Spinazola, Mrs. Ralph Richter, and Faith Cushing.

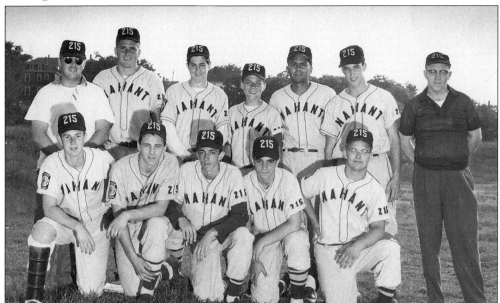

The American Legion sponsored a baseball team for many years. Pictured here in the mid-1950s are the following, from left to right: (front row) John McCann, Bill Szczaninski, Kenny Oliver, Haskell Jaffe, and Andy O'Shea; (back row) Coach Jim Brown, Phil Tamis, John Demarco, unknown, Bob Nickolau, Billy Stevens, and Coach Joe McDonough.

For many years, when winters were more consistently cold, the fire department would create a skating rink at the Lowlands playfield by building up a small berm around the area and filling it with water. Catsy Fowle lends some support to her daughter Cally in January 1959. (Courtesy Catsy Fowle.)

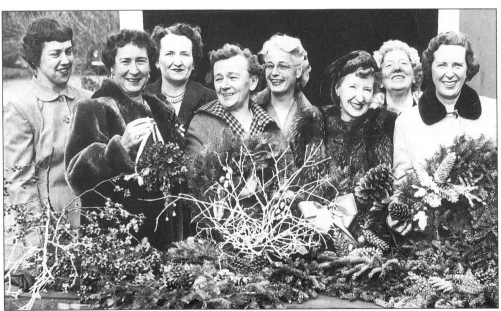

The Nahant Garden Club in the late 1950s shows off holiday decorations for the Christmas flower show and sale. Formed in 1927 and active to this day, the club promotes gardening and the beautifying of Nahant. Shown are Nici Devens, Dot Hart, Mary Flint, Reba Timmins, Dorothea Bangs, Bea Shea, Josephine Follen, and Liz Butterworth.

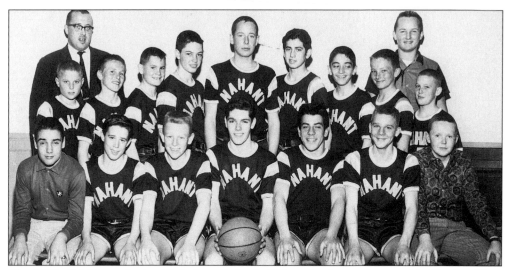

The 1959–60 Nahant Junior High Boys Basketball Team had a good year with 22 wins. They are, from left to right, as follows: (front row) Ronnie Murphy, Mike Enzinger, Tom Smith, Dave Giarla, Richie Nobrega, Jackie Joyce, and Beirne Lovely; (back row) Dave Durnam, Moe O'Connor, Larry McDonough, Greg Collins, Dave Hussey, Jack Pepadinis, Mike Michaud, Kevin Salt, and Miles Leavitt, with Coach James Brown and Tom Nelson behind.

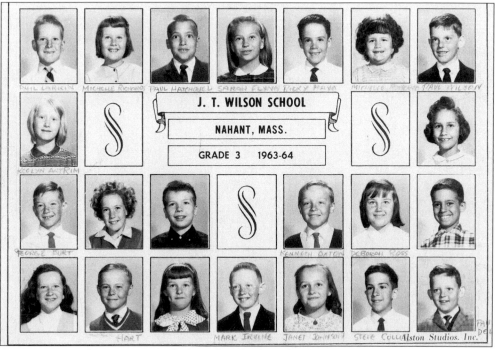

Twenty-two students were enrolled in the third grade class of the J.T. Wilson School in 1963–64. They are, from left to right, as follows: (bottom row) unknown, John Webster, Cheryl Champany, Mark Irvine, Janet Johnson, Steve Collins, and Paul Deleney; (second row) George Burt, Mary Britt, unknown, Kenneth Oxton, Deborah Ross, and unknown; (third row) Keelyn Atrim and Patty Bongiorno; (top row) Phil Larkin, Michele Richard, Mike Hart, Sarah Flynn, Ricky Mayo, Michele Roberio, and Paul Wilson.

Tidal swimming pools used to be common in coastal communities. These were constructed right on the rocks and were either directly or indirectly filled by the rising tide. On the left, the pool at the Cary Street Club in 1963 has just been filled by the pump. It took two tides to fill and if the ocean was cold there might be a three-day wait for it to warm up. On the right Sally Fowle tests the temperature in July 1964. (Courtesy Catsy Fowle.)

The Fourth of July is celebrated with panache at the Cary Street Club. Prizes were given out at the awards table for races. David Hall (foreground) has just received two ribbons. At the table are Peggy Richardson, Alice Bryant, Susan Hammond, and Charlie Kettell. (Courtesy Hall family.)

The 80-foot, 90-ton dragger *Valiant* was built by Raymond Palombo and Frank McClain Jr. in the yard between their homes on Forty Steps Lane over a six-year period. The move toward Tudor Wharf in October 1963 provided excitement for the whole town, culminating in the ship's christening by ten-year-old Alma Palombo. In the foreground are Alfred Arzillo (left) and Robert Enzenger. Officer Joseph Flynn, Louis Le Tourneau (in the knit cap), and an unidentified neighbor discuss the event. The *Valiant* later sank 70 miles east of Nantucket with no loss of life.

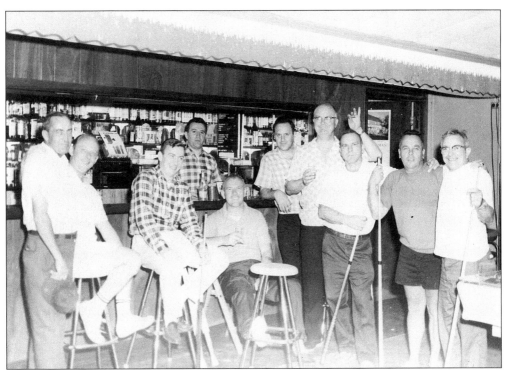

Several pool players and their friends "mug it up" for the camera at the old Knights of Columbus hall in 1963. The Knights had taken over the former roller skating rink of the Relay House and converted it to their hall. From left to right are Francis O'Connor, Al Carpenter, James Waldron, Dick Travesty, Frank Cullinan, Tony Dellagratti, Basil Robinson, Leo Moleti, Frank Hunter, and Ralph Torenzi.

Max Hall, Billy Lowell, and Gordie Hall pose on the go-cart they built in 1966. They are in the cellar hole of the George Peabody house, later owned by Dudley B. Fay. It burned in 1958 because of arson, shortly after the Hall family purchased the property. (Courtesy Hall family.)

Two beach bums use their imagination to enjoy Joe's Beach around 1960. Gordie (Gordo) Hall is on the left and David Hall is on the right, in the middle of a comment. (Courtesy Hall family.)

Friends and relatives are enjoying Kevin Carey's fifth birthday party on September 15, 1969. Clockwise from the bottom are Mary Elizabeth Carey, Sally Fowle, Mrs. Maureen Carey, Nathan Clapp, Lisa Carey, Heather Murphy, Danny Carey, and George Carey. (Courtesy Bob and Mary Carey.)

Nahant has a long history of holiday regattas dating back to 1845. The event of July 19, 1845, was the first yacht race in Massachusetts. In 1967 the National Town Class Championship Regatta was held by the Nahant Dory Club. This photograph shows the start of the event. The boat in the foreground is the *Two Q's*, owned and skippered by Nahanter Robert Cusack.

James Brown, who served as a Nahant coach from 1958 through 1992, identified the members of this winning 1968 Nahant Junior High Basketball Team by their last names. They are, from left to right, as follows: (front row) Larkin, Delany, Migliaccio, Dragon, McKenna, B. Doran, N. Doran, and Williams; (second row) Coach Jim Brown, W. Wilson, Murphy, Famulari, Brewin, Merlino, Malone, Santaruono, R. Savage, and Sullivan.

On May 9, 1965, a spectacular fire consumed Lowlands, built by George Abbot James at East Point. This landmark building, after serving the U.S. military, was vacated and vandalized before its destruction.

Coach James Brown's junior high basketball team is all smiles in this 1970 group portrait. Clockwise with Coach Brown are Ray Fortucci, Ricky Kane, David Oxton, Brad Smith, Ken Oxton, Bill Swansburg, Mark Palombo, unknown, ? LeBlanc, Paul Delaney, unknown, Daniel Doran, Timmy Moran, Phil Larkin, Dave Rowland, and Steve Collins.

Tony Conigliaro obviously enjoyed other sports besides baseball. Three years after graduating from St. Mary's High School in Lynn, he became the youngest player ever to lead the league in home runs. Later he and his brother Billy, teammates on the Boston Red Sox, set a home run record for brothers. The Conigliaros bought the Drumquill Golf Course in 1972 and Tony and his father, Salvatore, built the clubhouse in the left background, appropriately named Tony C's. The function hall on the right, the Ocean View, was also owned by the family in the 1970s, when it was Tony C's Country Club.

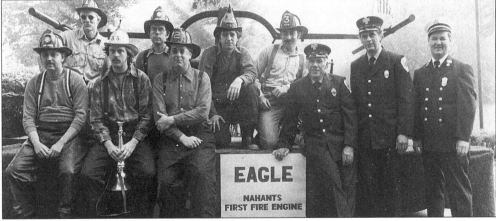

Nahant, like towns and cities all across the USA, celebrated our nation's bicentennial in 1976. Over the three-day July Fourth weekend numerous events took place including a square dance, an open house at the Whitney Homestead, skydivers jumping over Short Beach, water sports and games, and a baby contest, ending with a cookout at Marjoram Park. Members of the fire department and call-men are shown here posing in front of the old Eagle. From left to right are John Hatfield, Tom Walsh, Paul Wilson, Brian Doulette, Bob Lehman Sr., Richard Comeau, Dennis Forbush, Jack Dougherty, Ray Robidoux, and Chief John Quinn.

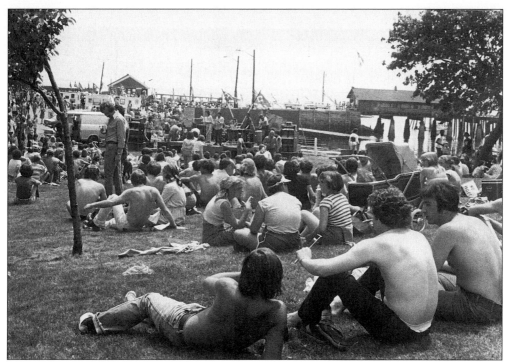

From 1968 to 1988, Nahant Arts held a festival, a celebration of painting, arts and crafts, and music, each Memorial Day weekend at the town hall and the Coast Guard Station, and later at Tudor Wharf. On this warm weekend, a musical group performs for the crowd.

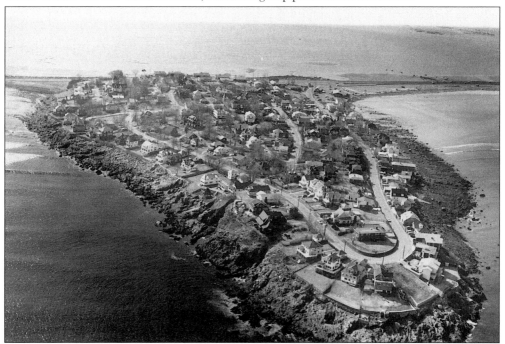

The rocky coast and the density of the population of Little Nahant is clearly visible in this aerial view of 1979–80 from the east looking west. (Courtesy Lynn Museum.)

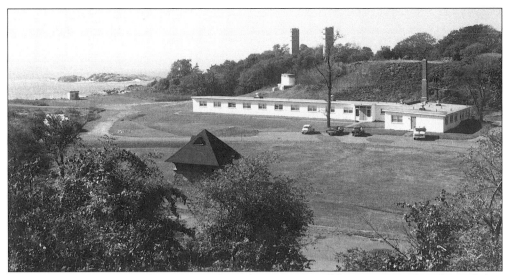

Remnants of Nahant's 20th-century military history can still be seen even though much has been demolished, battered by the sea, or converted to other uses. This 1970 photograph shows two examples of the latter. The Northeastern University Marine Lab at East Point (in the middleground) was converted from the enlisted men's barracks and officers' building. Behind this building can be seen the eight-story concrete twin towers built on the Lowell estate. These fire-control stations were one group of units built throughout Big Nahant to track, spot, and observe seagoing vessels. The small stone building in the foreground, originally an icehouse, is all that remains of the great Lowlands estate built by George Abbot James.

People remember the Blizzard of 1978 so well, it seems to have overshadowed the other winter storms of that year. The storm of January 22, 1978, also wreaked havoc on the island community. Stranded, snowbound cars on the Nahant Causeway were previews of the bigger storm to come. It took the National Guard to help clear the causeway.

The day after the Blizzard of '78 was a beautiful sunny day. Driveways had been shoveled but the plows hadn't come yet so no one could get out. Catsy Fowle did not want to "waste a ray of sunshine." She can still be seen in this position at her home on Greystone Road on warm summer days—but without the winter gear. (Courtesy Catsy Fowle.)

This contemporary view of Bass Point demonstrates how densely packed it is. A World War II fire control station has been incorporated into a private house. As one can see, everyone tries to take advantage of the spectacular views. (Courtesy Lynn Museum.)

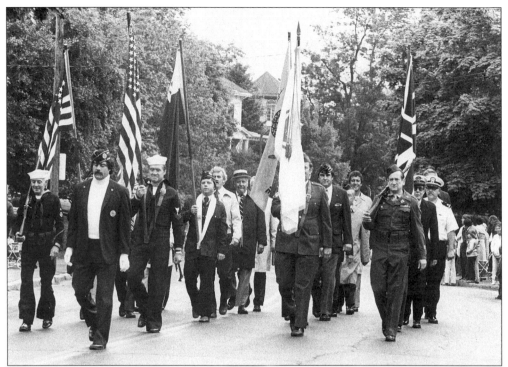

Veterans are showing the colors during the annual Memorial Day parade in 1979. From left to right are Richie O'Connor, Joe Fiore (leading), John Durnam, Wayne Noonan, Randy Kimball, Dick Savage (in the straw hat), Neil Foley (with the state flag), Richard Lombard, Andre Sigourney, Ted Roy, Dick Davis (with the gun), Harry Edwards, and Lewis Restuccia. (Courtesy *Lynn Daily Evening Item*.)

A common sight around Nahant are the lobster boats and the seagulls they attract. Year-round lobstering in Nahant dates back to 1858. Even in the 19th century, laws were enacted to prevent over-fishing; still very much a concern today. Many Nahanters continue to make their living from the sea.

Nahant has always offered spectacular views. Two people enjoy the view of the Boston skyline from Marjoram Hill Park on a fine June day in 1986. (Courtesy *Lynn Daily Evening Item*.)

BIBLIOGRAPHY

A Lady. *A Visit to Nahant: Being a Sequel to the Wonders of the Days*. New York: General Protestant Episcopal Sunday School Union, 1839.

Butler, Gerald W. *Military Annals of Nahant, Massachusetts*. Nahant, MA: Nahant Historical Society, 1996.

Elliott, Harmon. *CAS-EL-OT: Nahant, Mass*.

Lewis, Alonzo. *The History of Lynn, Including Nahant*. Boston: 1844.

"Nahant: One Hundred Years a Town." Official Centennial Book and Program. Nahant, MA: 1953.

Paterson, Stanley E., and Carl G. Seaburg. *Nahant on the Rocks*. Nahant, MA: Nahant Historical Society, 1991.

Triber, Jayne E. *A True Republican: The Life of Paul Revere*. Amherst: University of Massachusetts Press, 1998.

Wilson, Fred A. *Some Annals of Nahant, Massachusetts*. Nahant, MA: 1928. Nahant Historical Society: 1977.